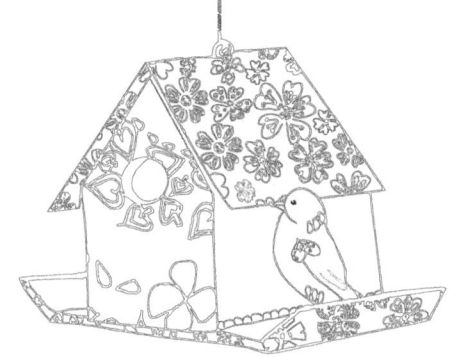

alexia's backyard

a nature inspired adult coloring book
to de-stress and self-express

by alexia liatsos

@2017 Alexia Liatsos. All Rights Reserved.

ISBN-13: 978-1544889207
ISBN-10: 1544889208

No part of this publication may be reproduced or transmitted,
in any form or by any means, electronic or mechanical, including photocopying,
recording or any information storage and retrieval system, without the prior
written permission from the author.

www.alexialiatsos.com

Welcome to my inky backyard!

Inside this book you'll find a dreamy black and white wonderland of intricate flowers, plants, bird houses and creatures waiting to be discovered and colored.

Alexia's Backyard is a celebration of the natural world, as much as it is a coloring and doodle book, waiting for you to lose yourself among the pages.
All the drawings in this book were created by hand using fine liner pens.

tips:

- Use the blank page at the back of this book to test your materials.

- Each illustration is perfect for decorating with pens, colored pencils, markers, or crayons.

- Pencils are the most versatile medium for coloring, as they will allow you to blend your colors and add shading if you wish.

- To help prevent bleed-through, place a blank sheet between the pages when coloring.

- Share your colored masterpieces with a friend or post a picture on social media with the hashtag #AlexiasBackyard !

Now, it's YOUR turn...

YOU! Yes - YOU - get out there and create a wonderland of colors!

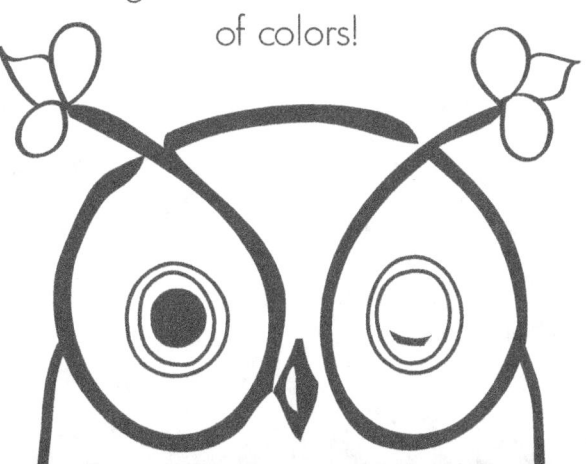

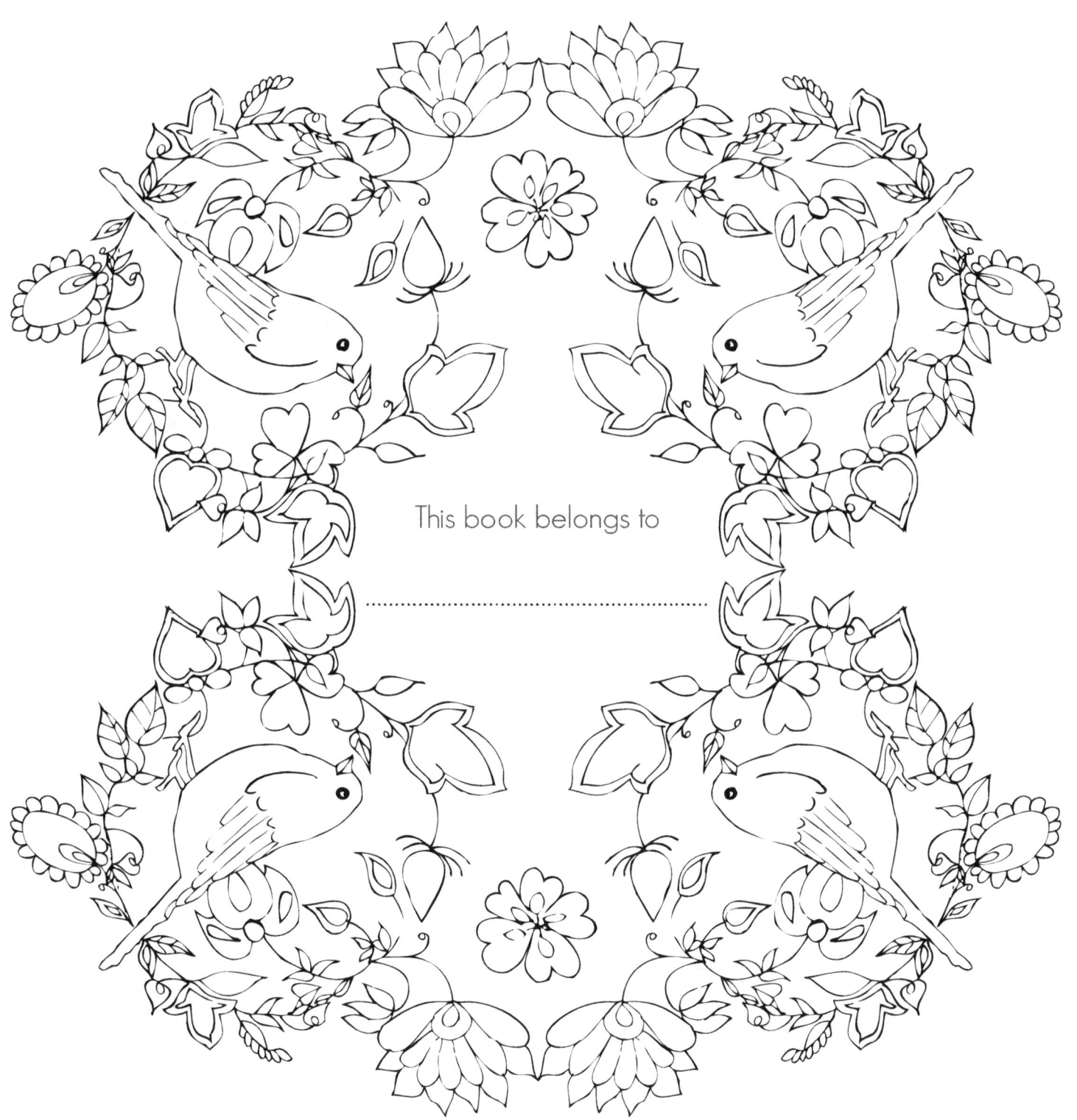

This book belongs to

..

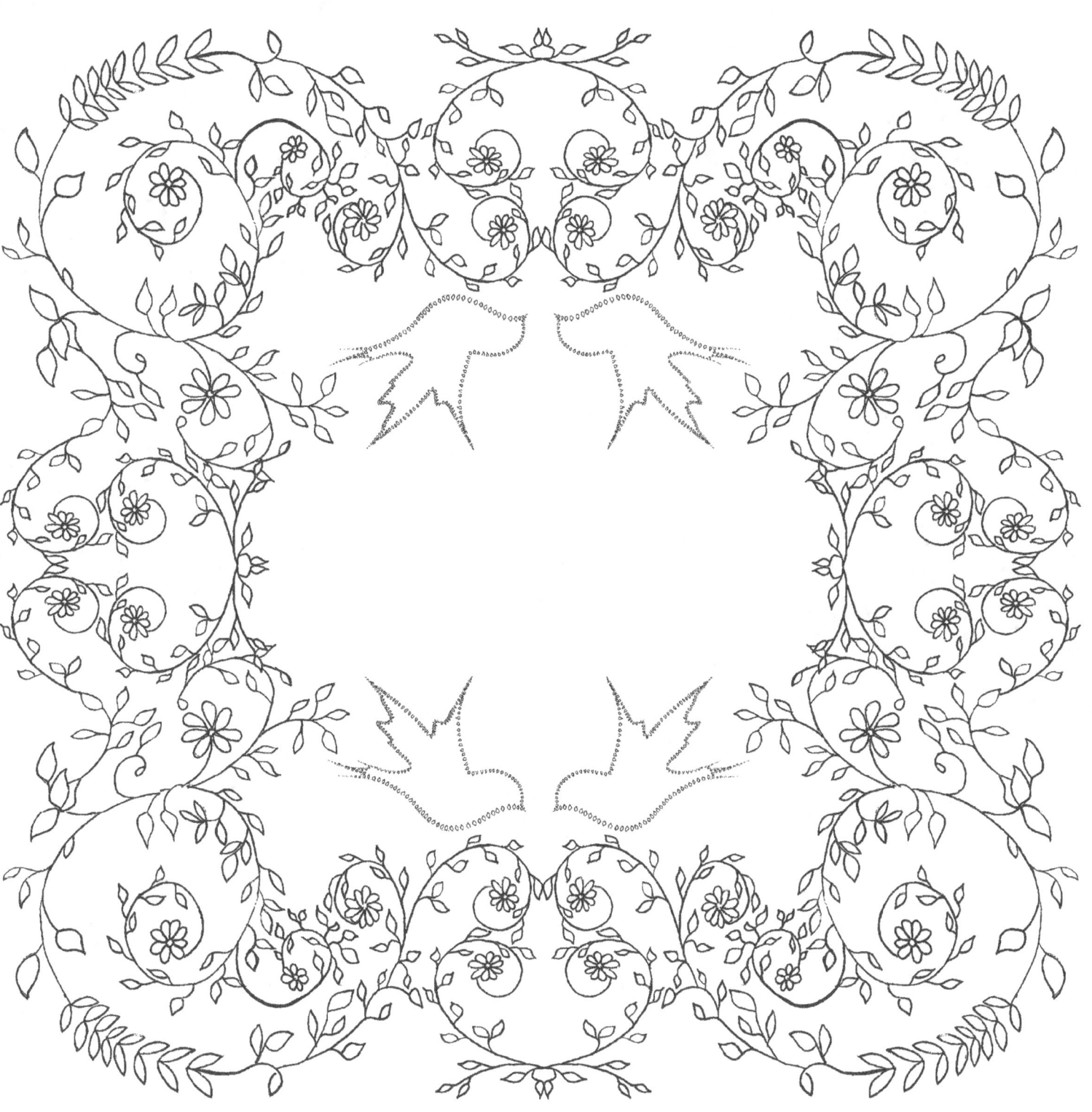

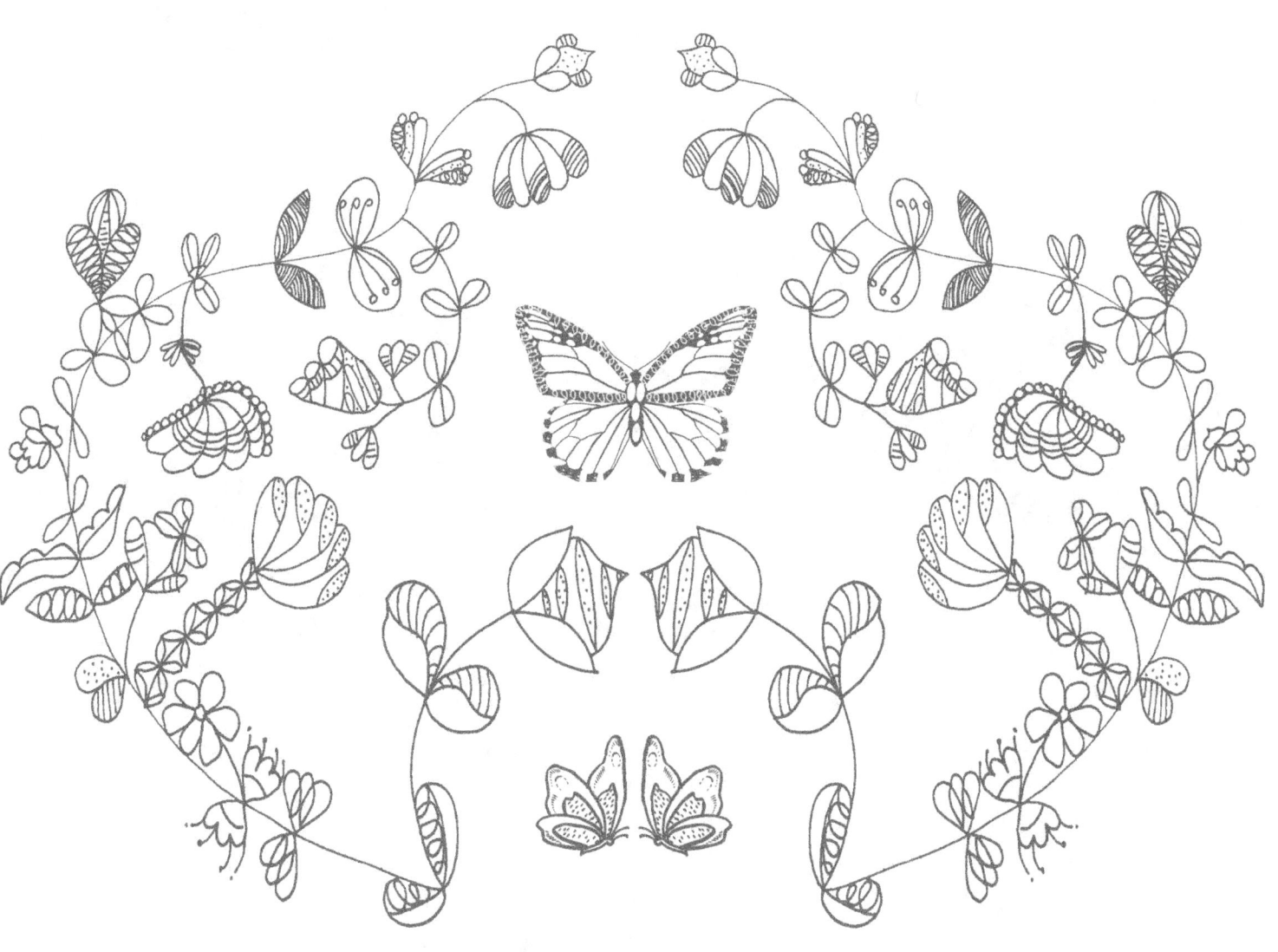

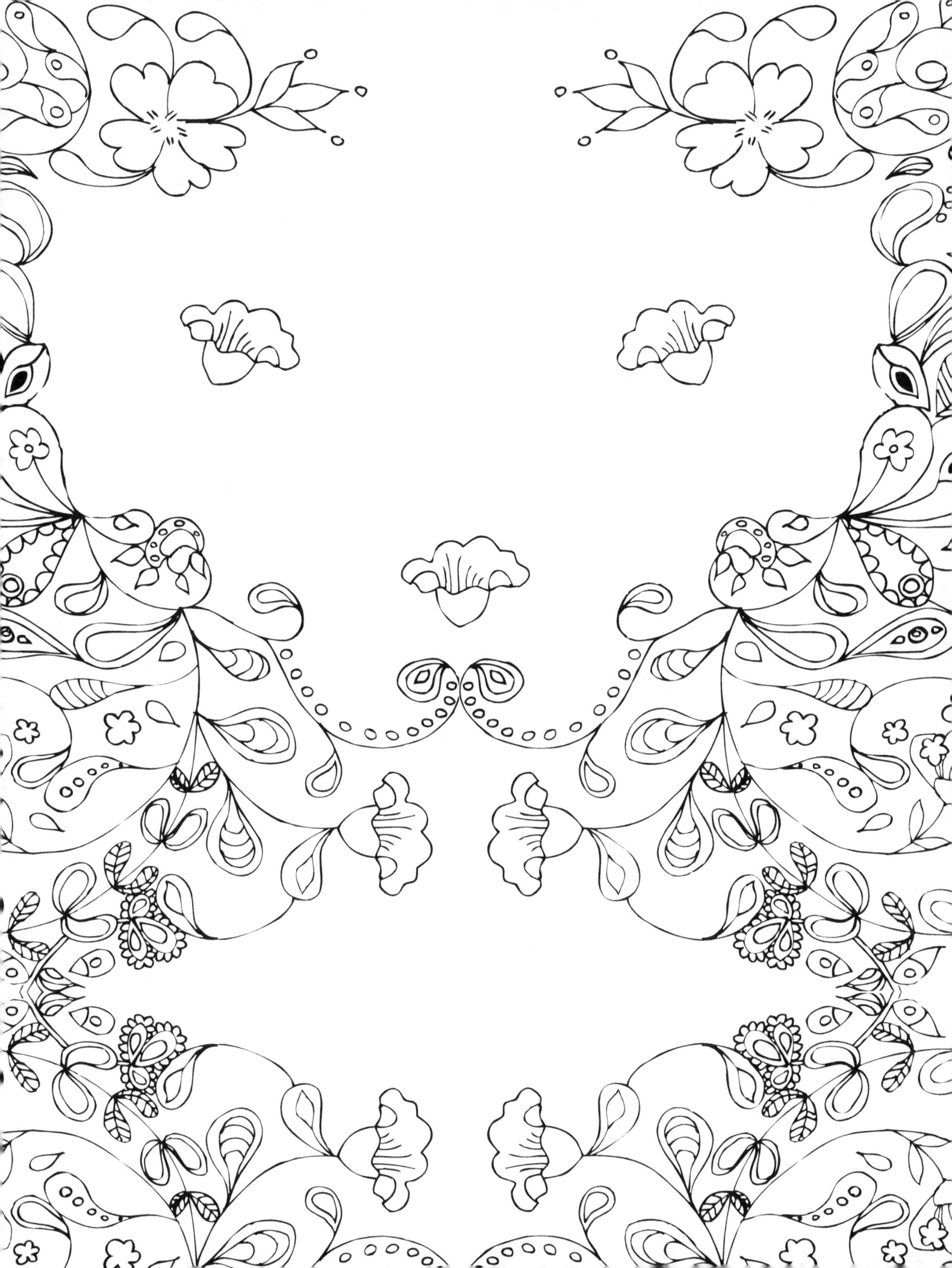

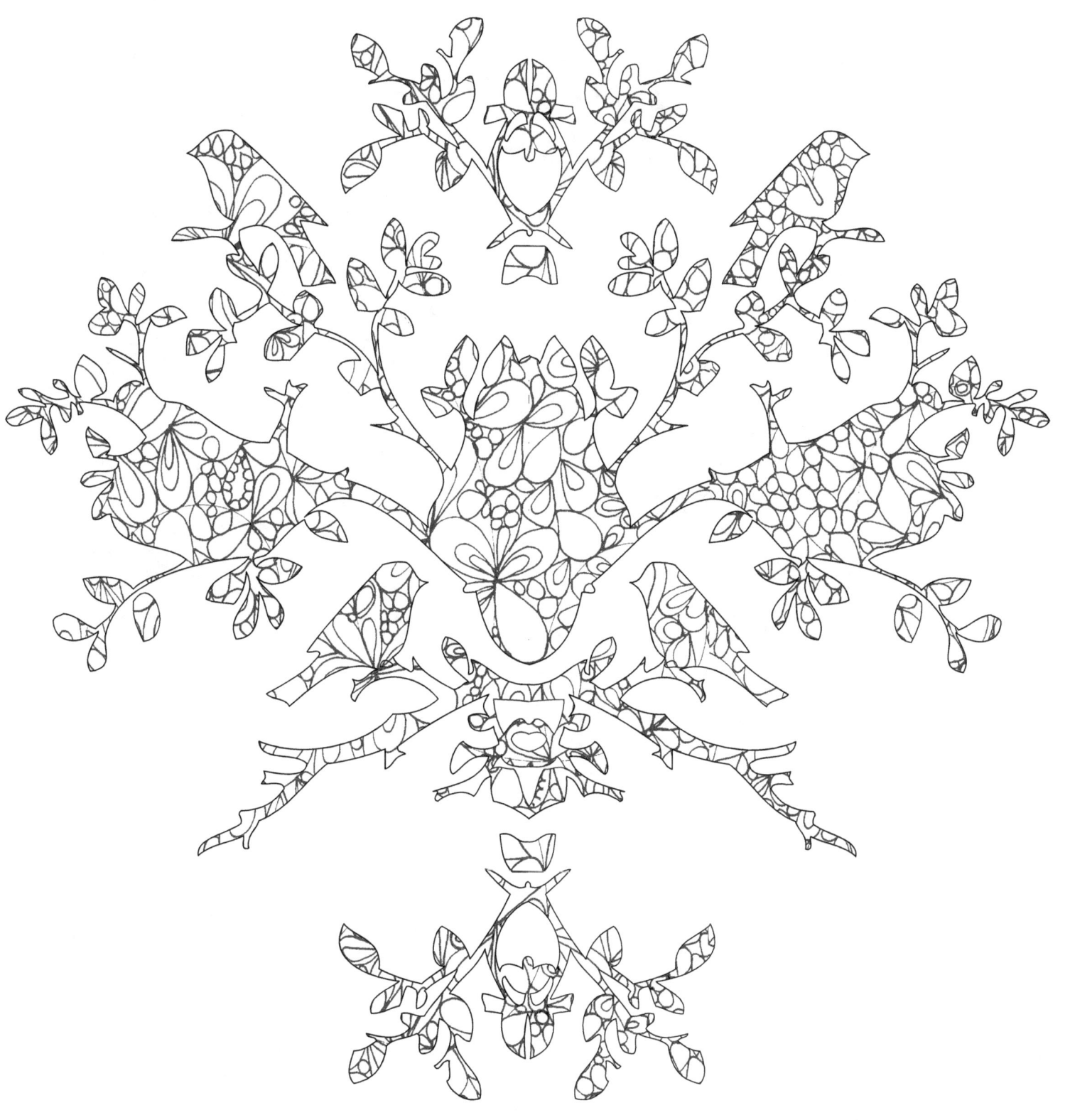

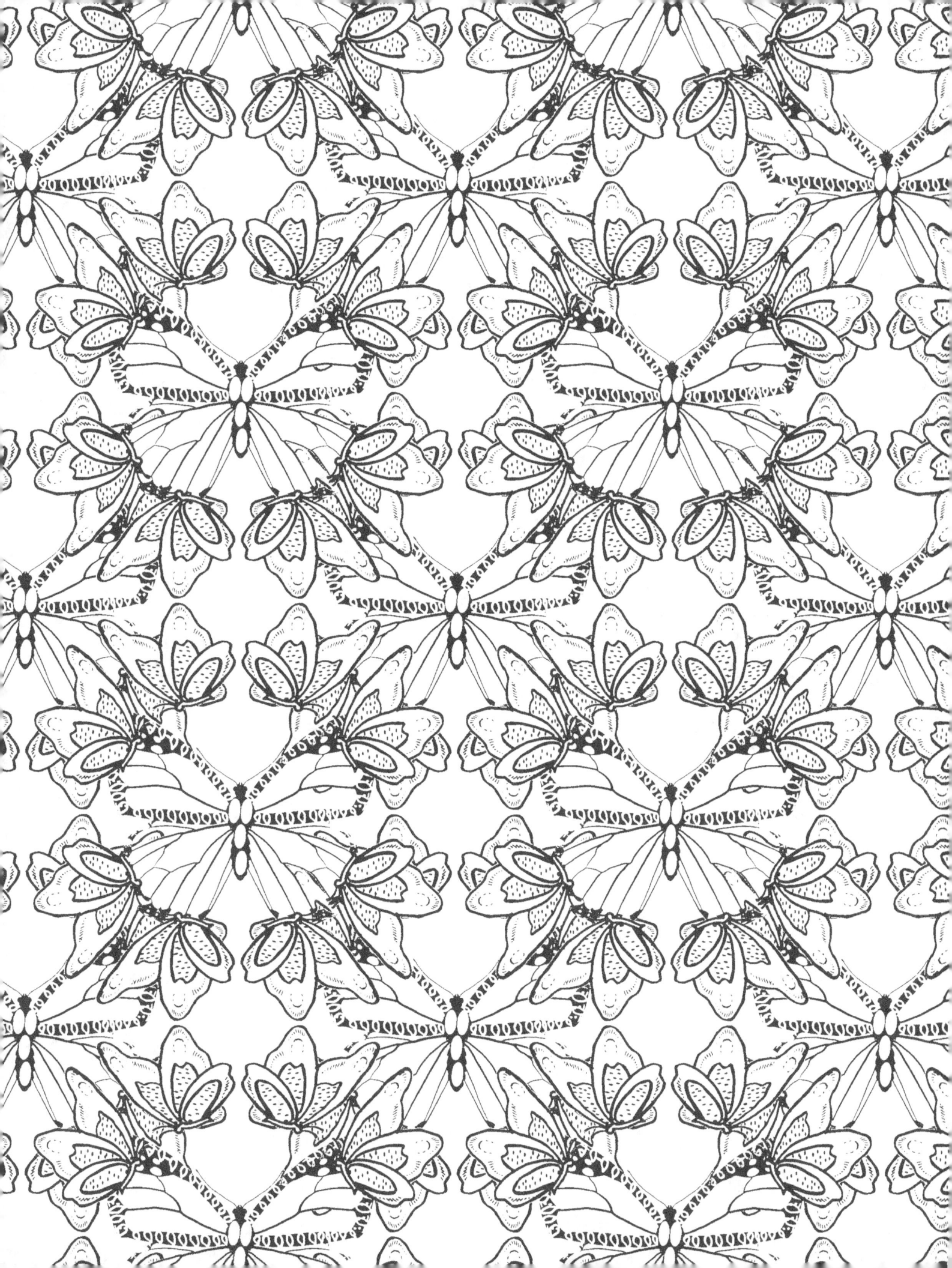

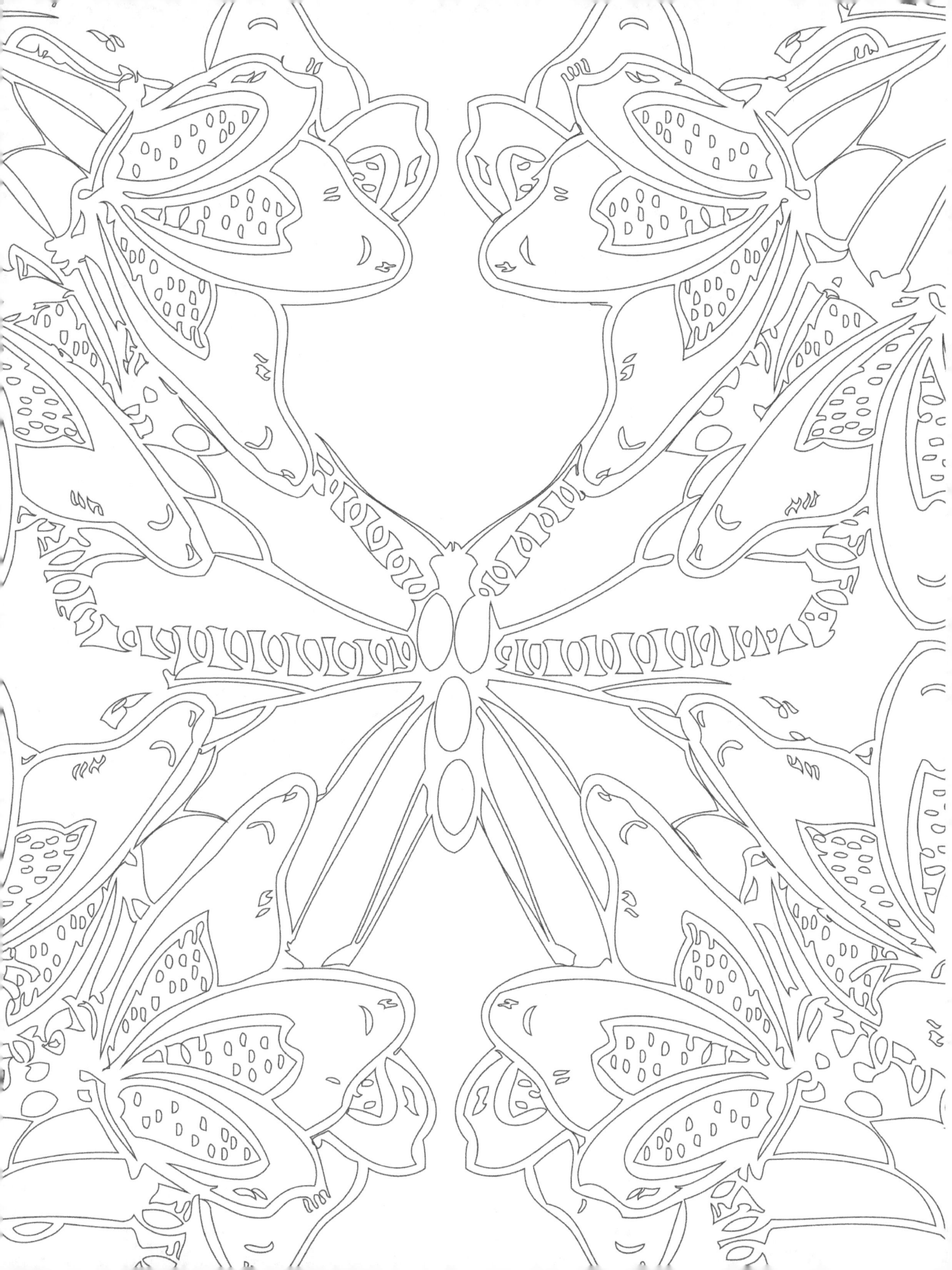

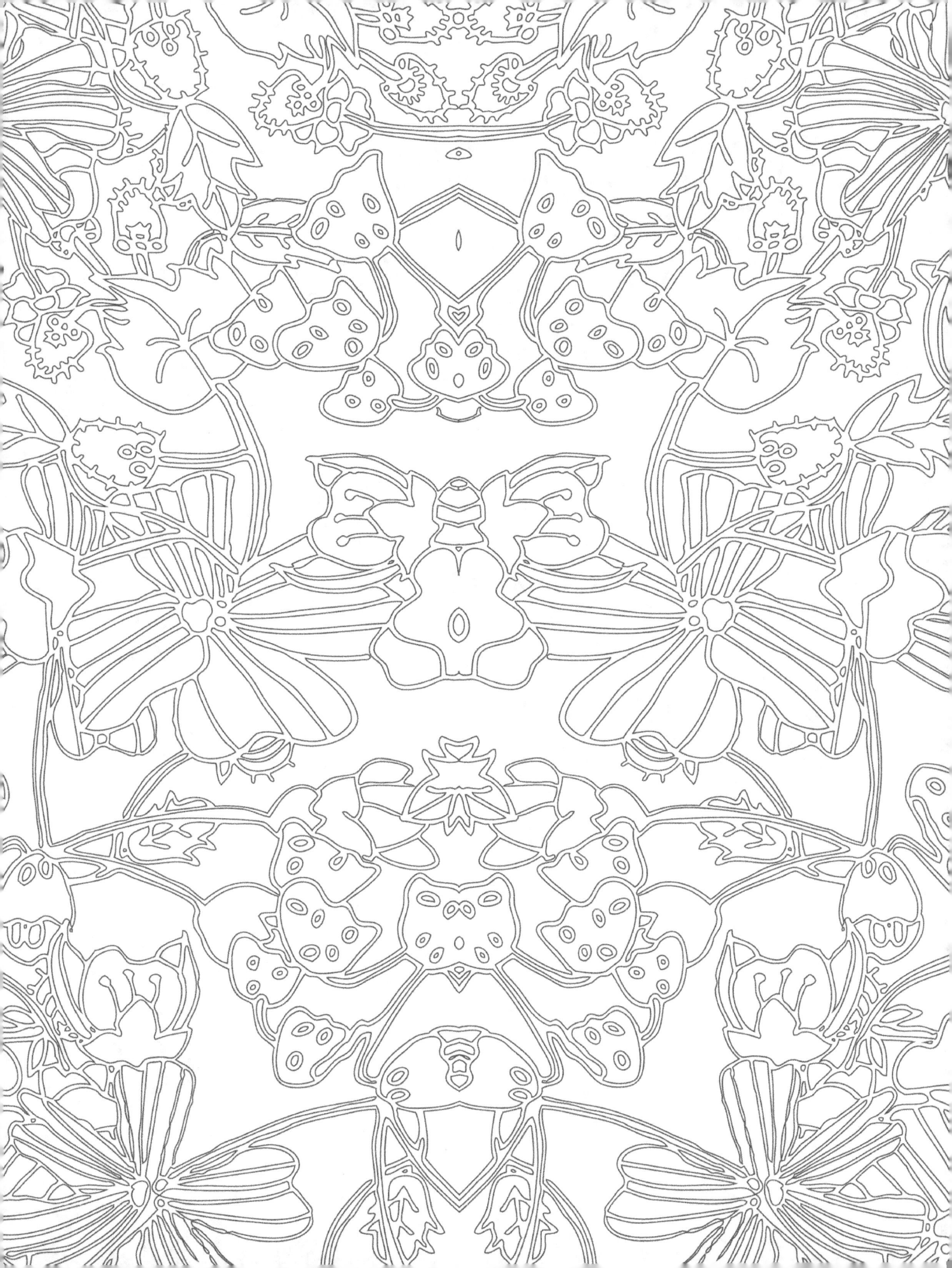

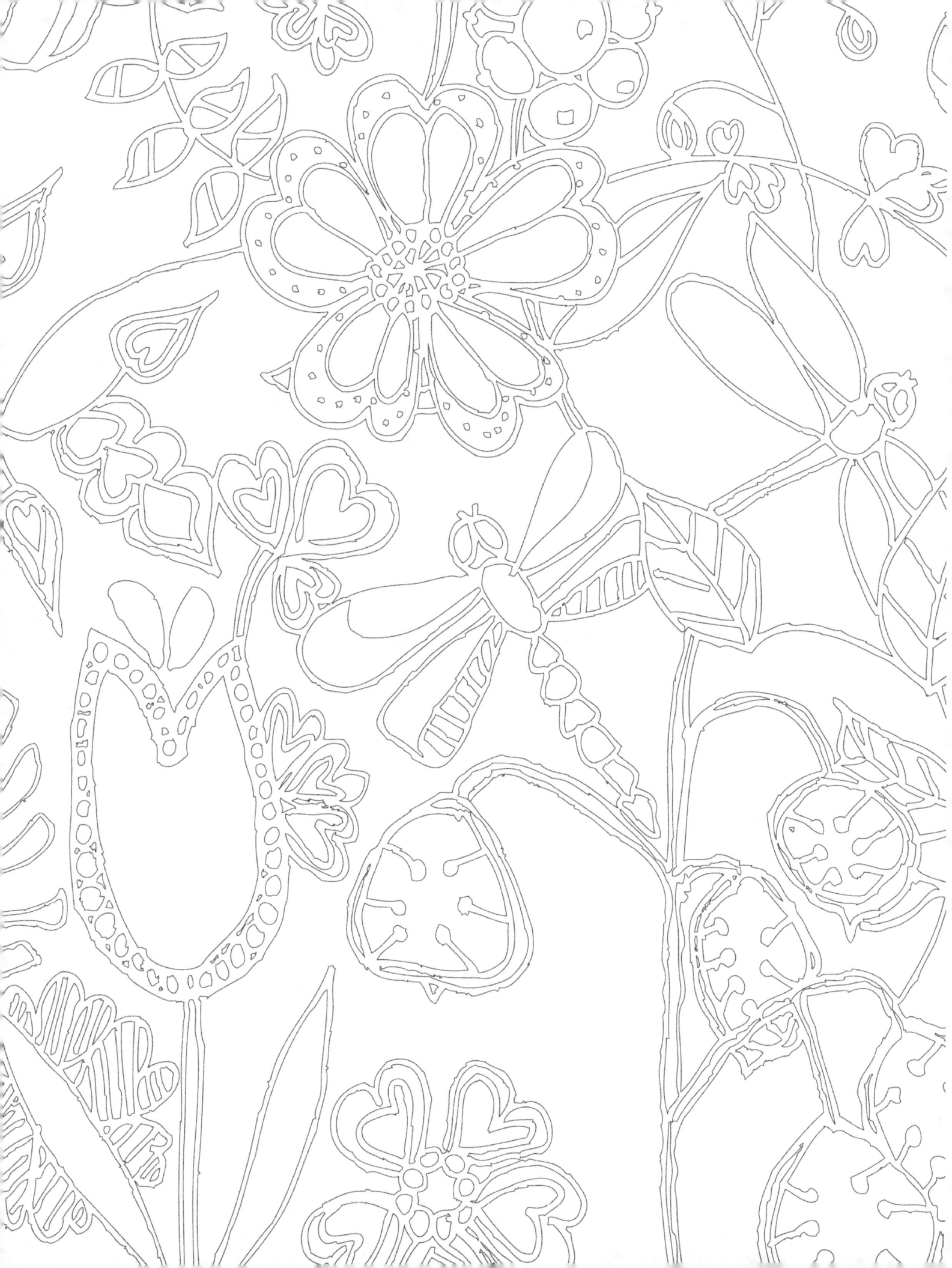

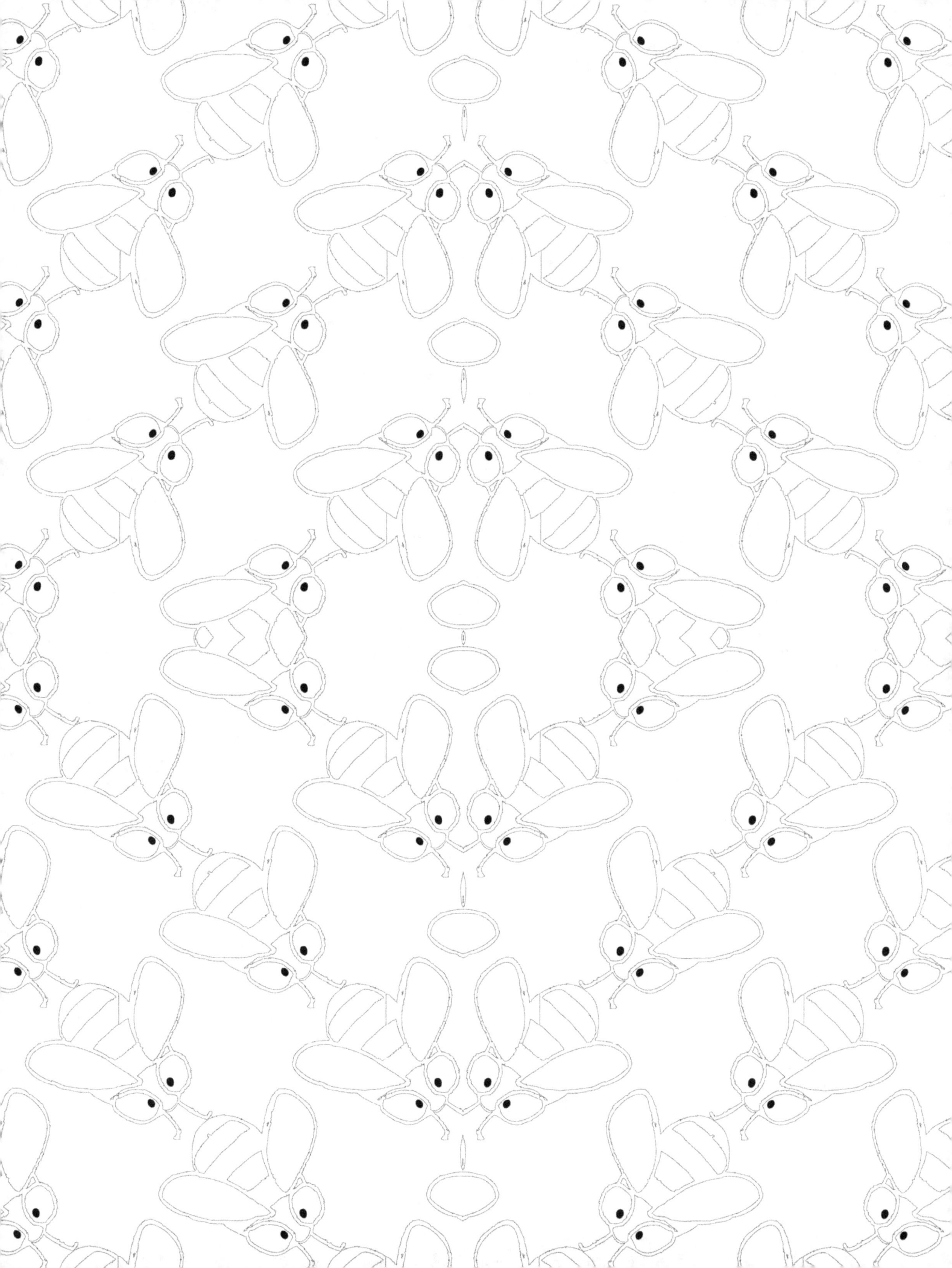

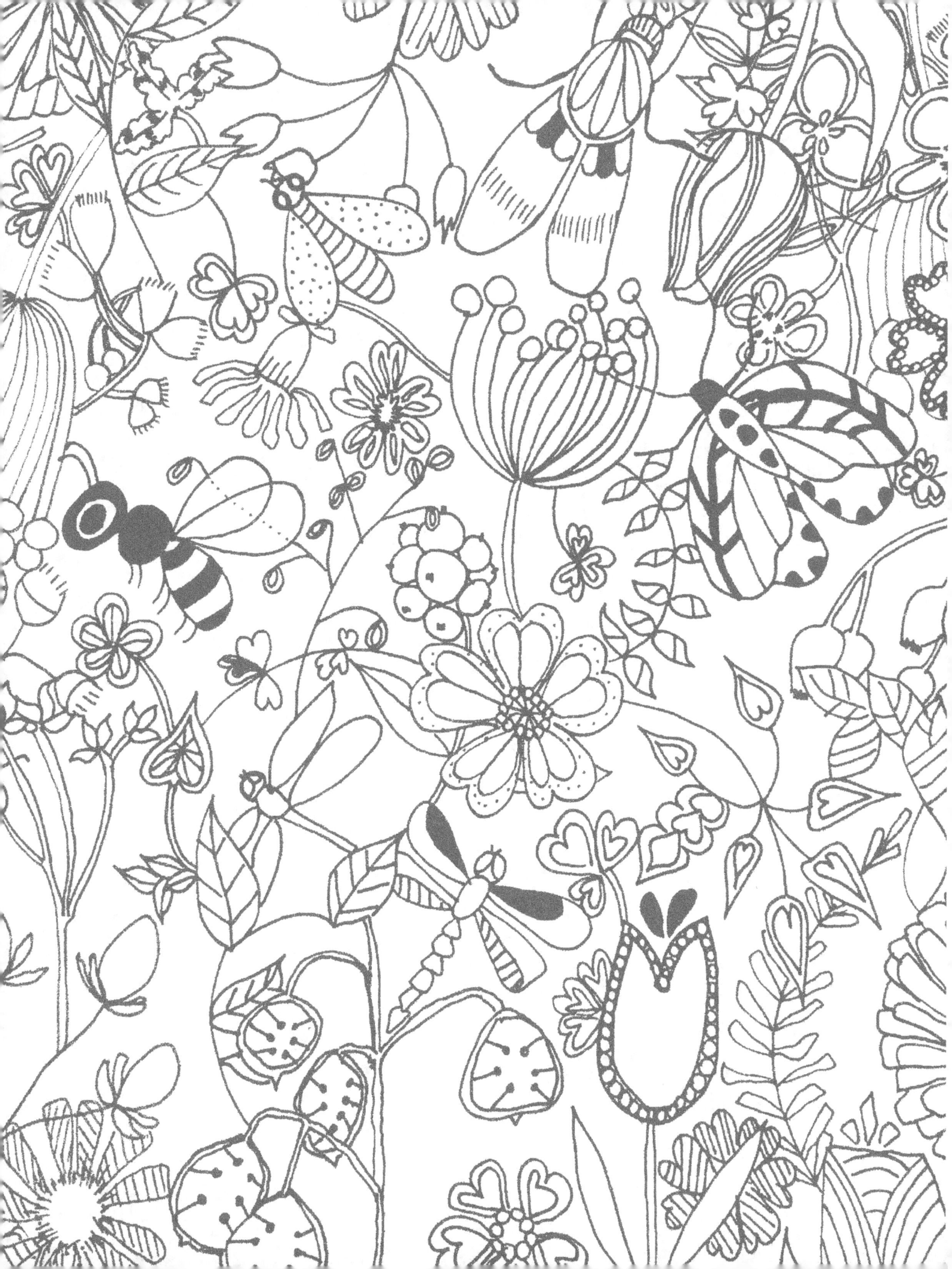

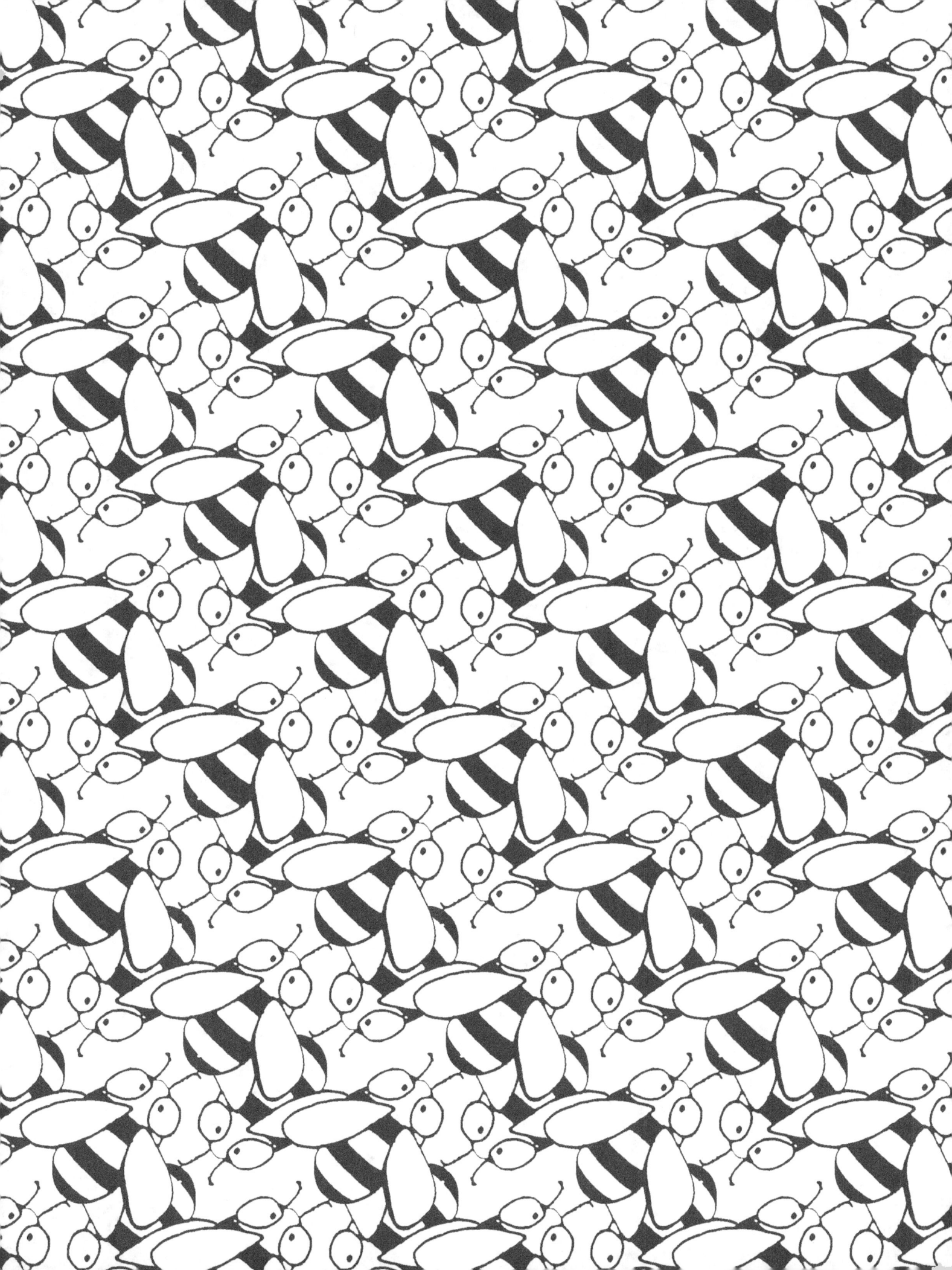

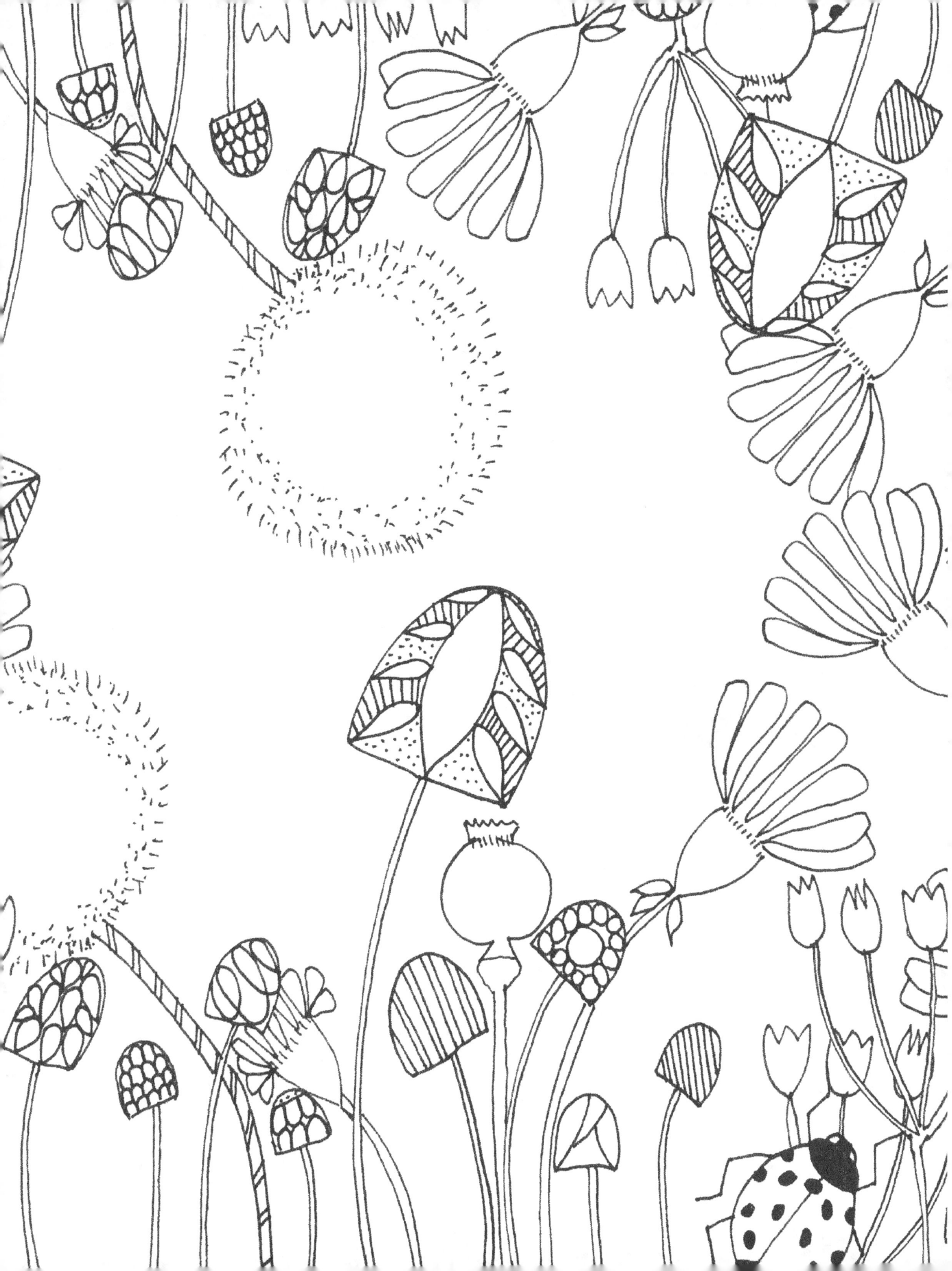

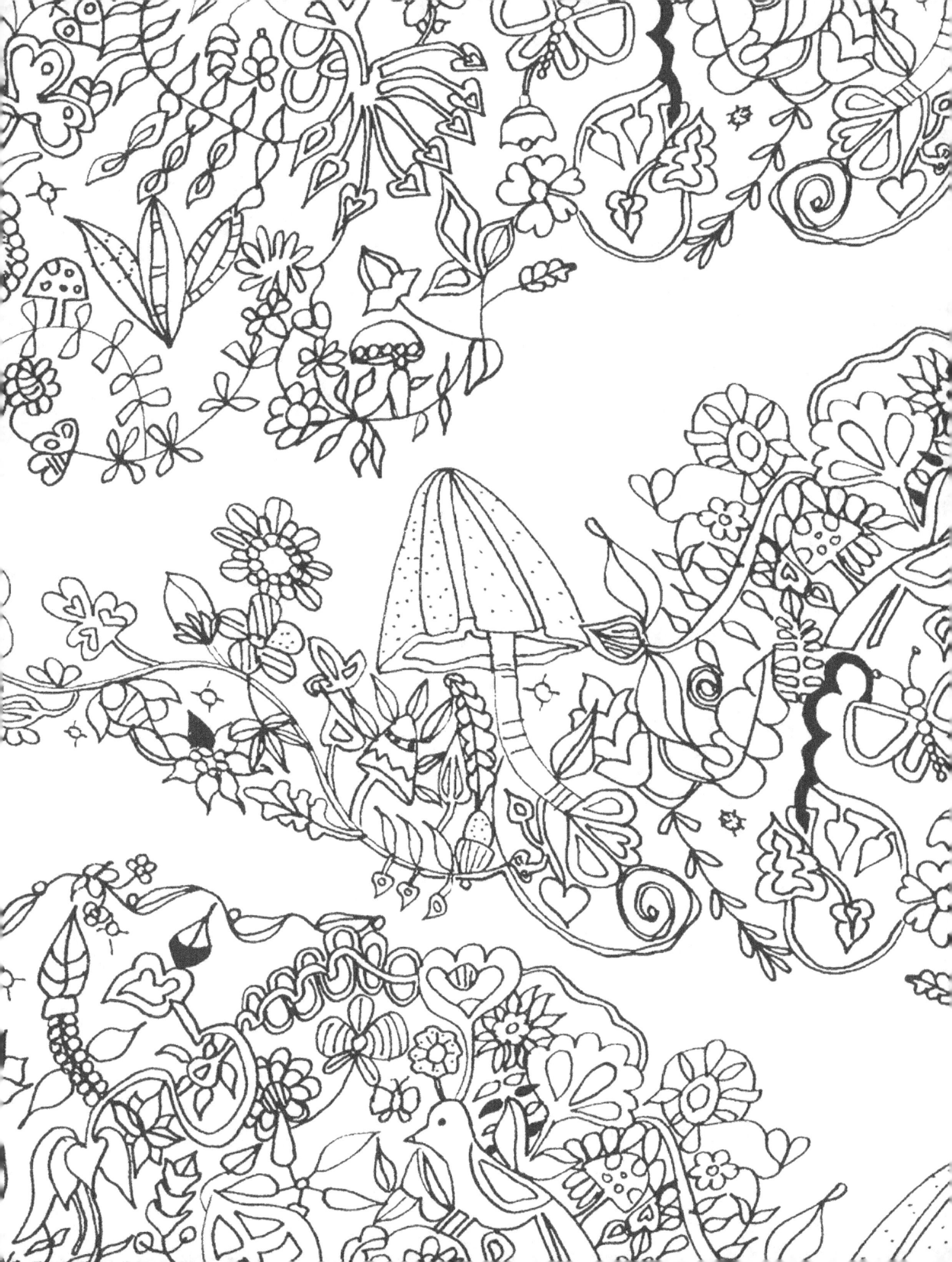

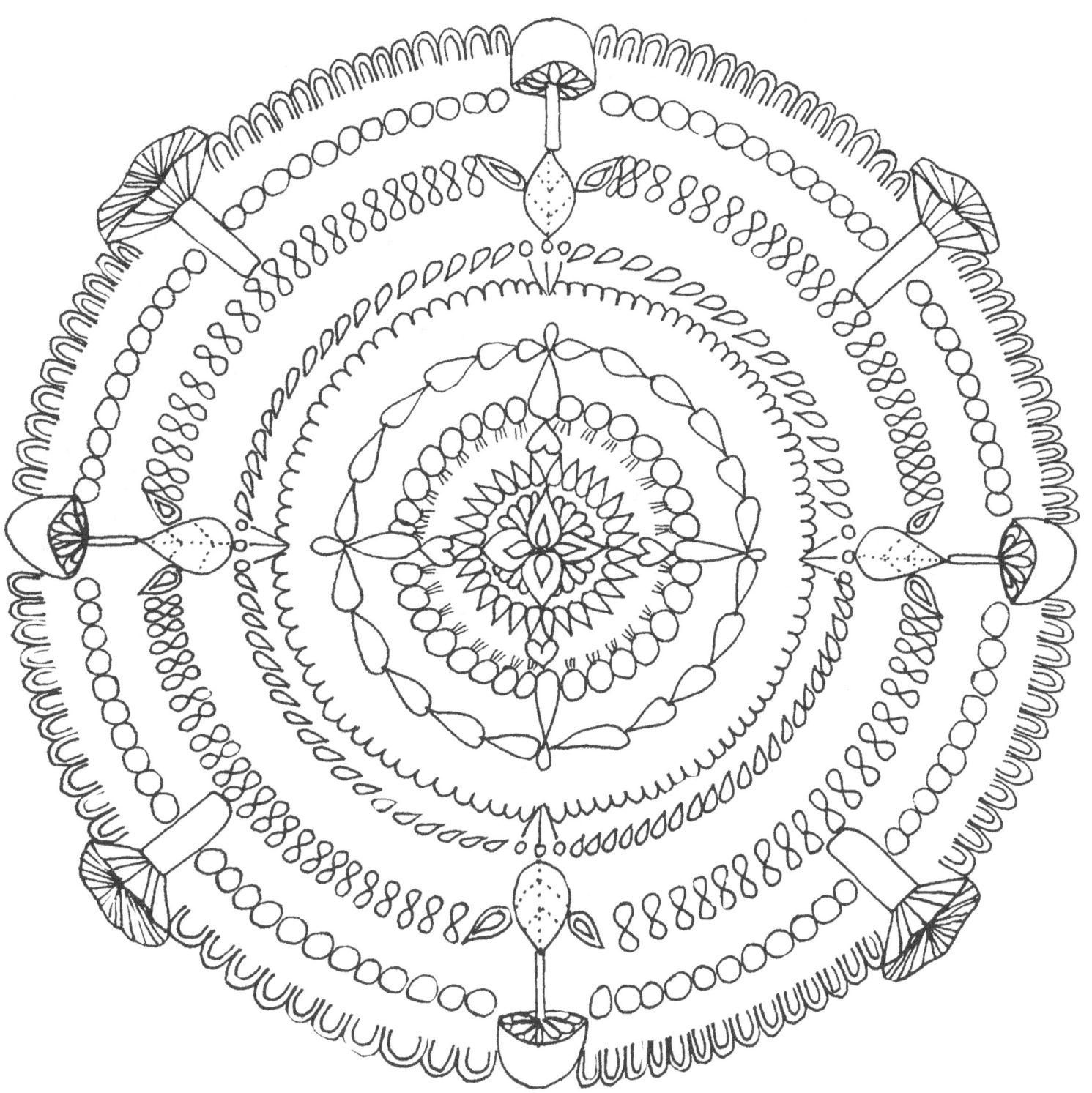

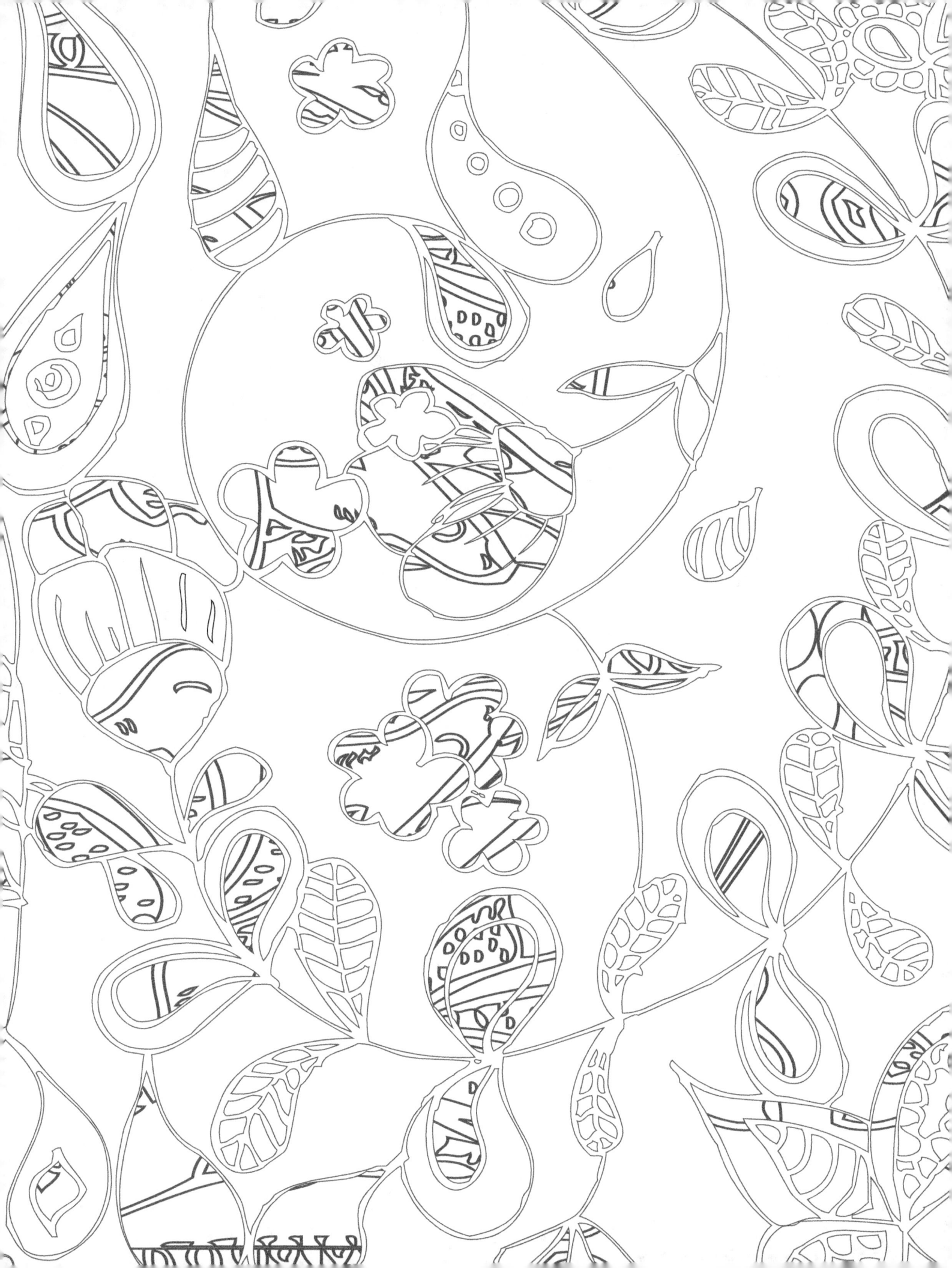

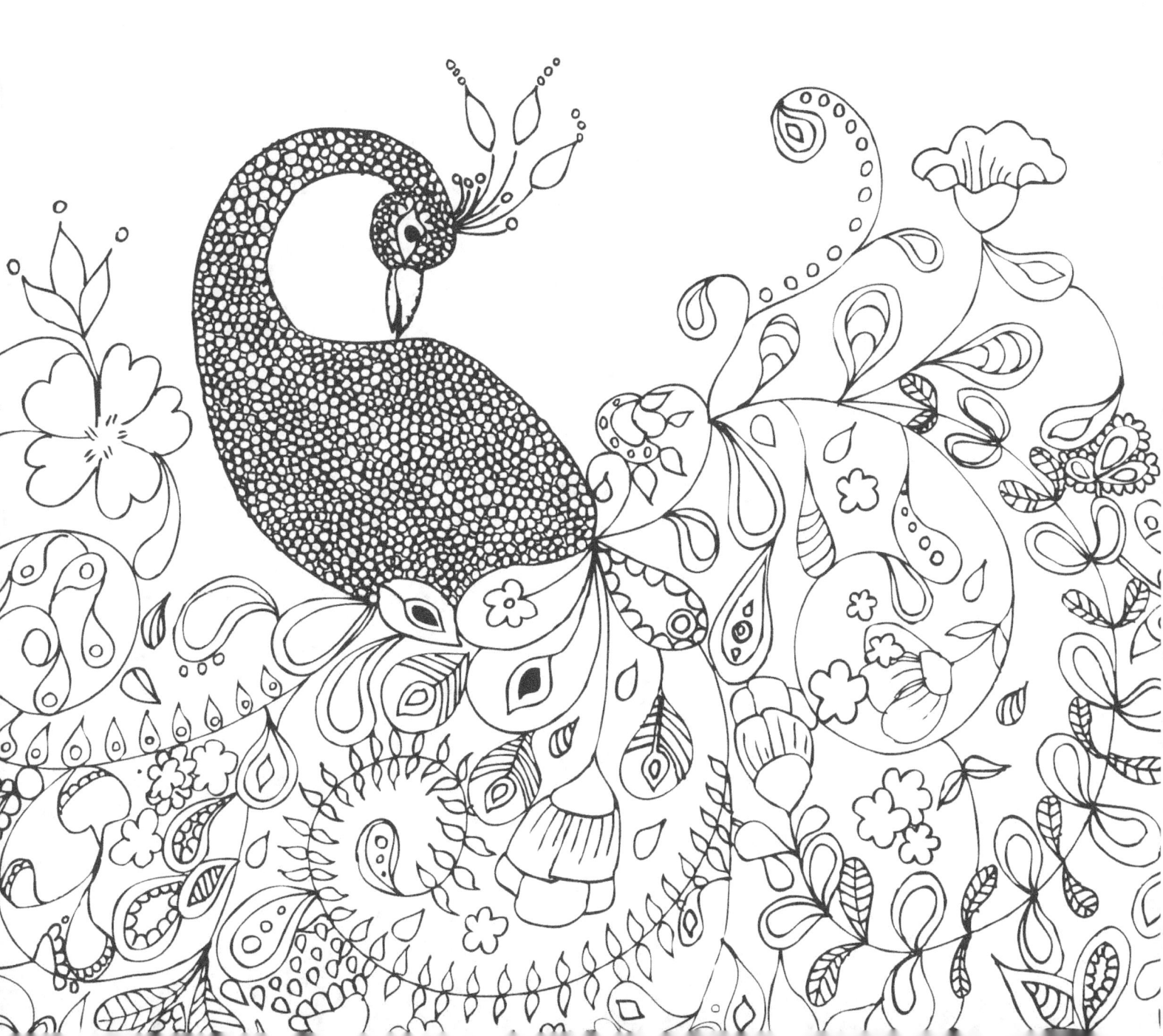

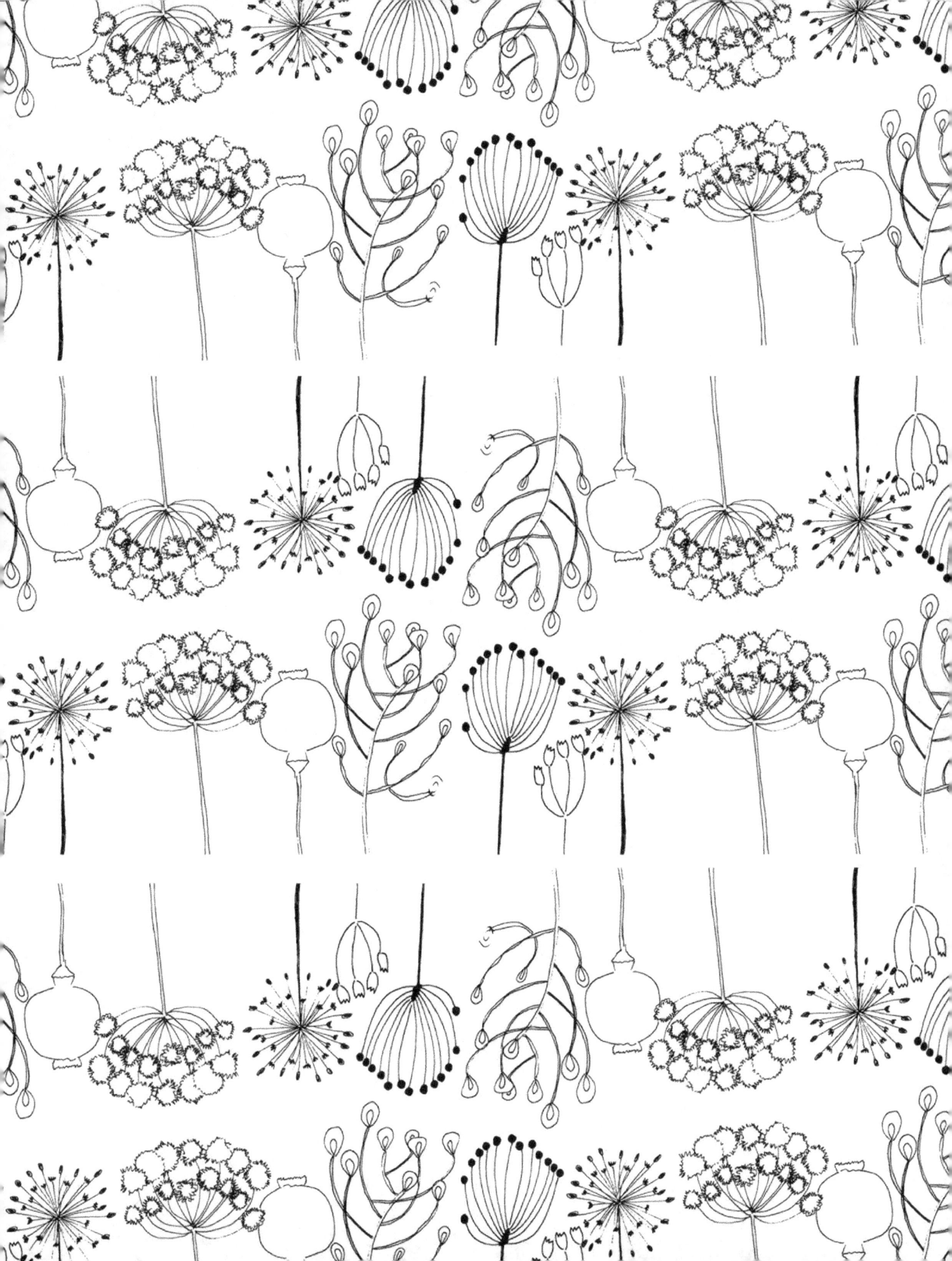

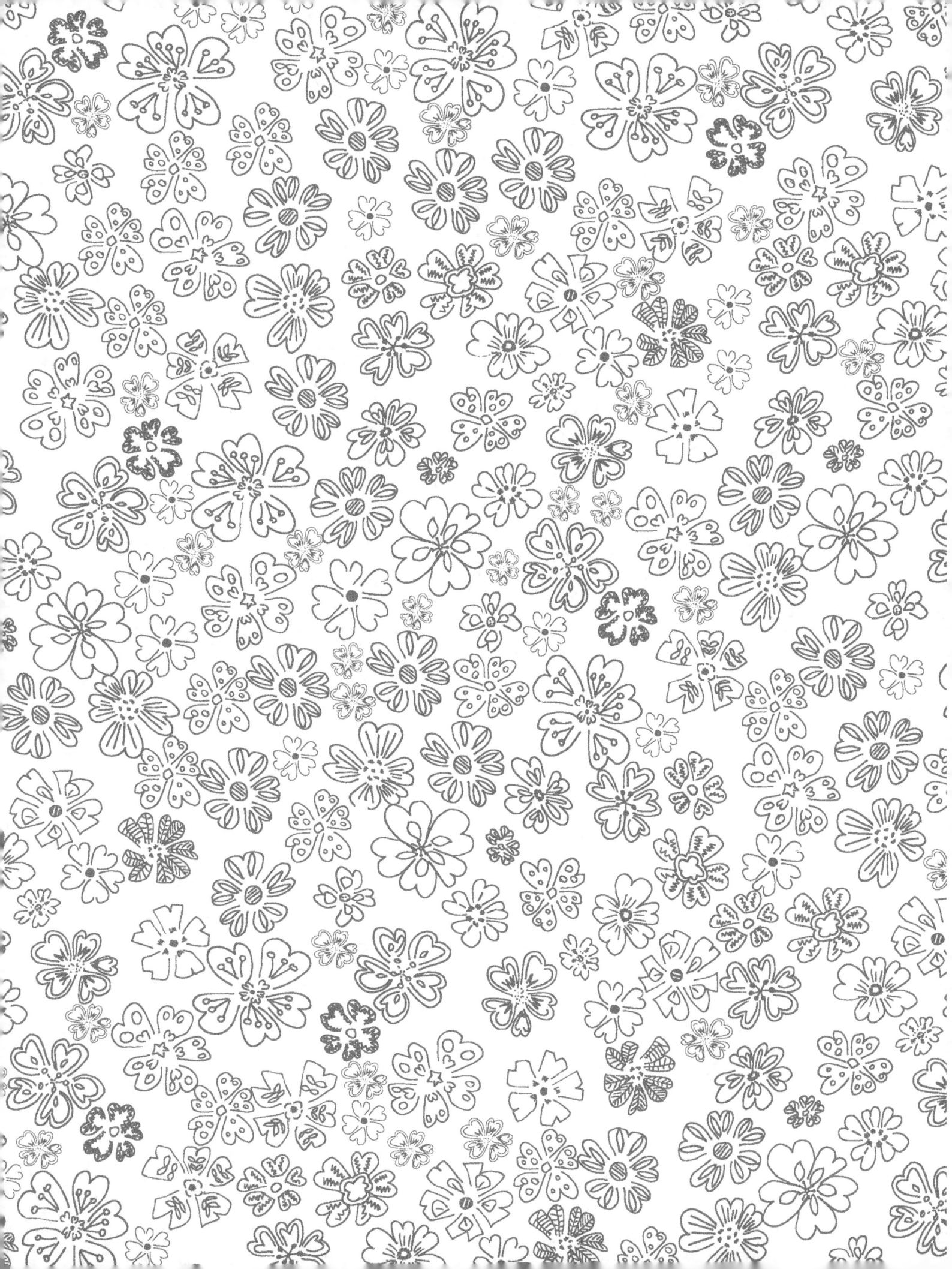

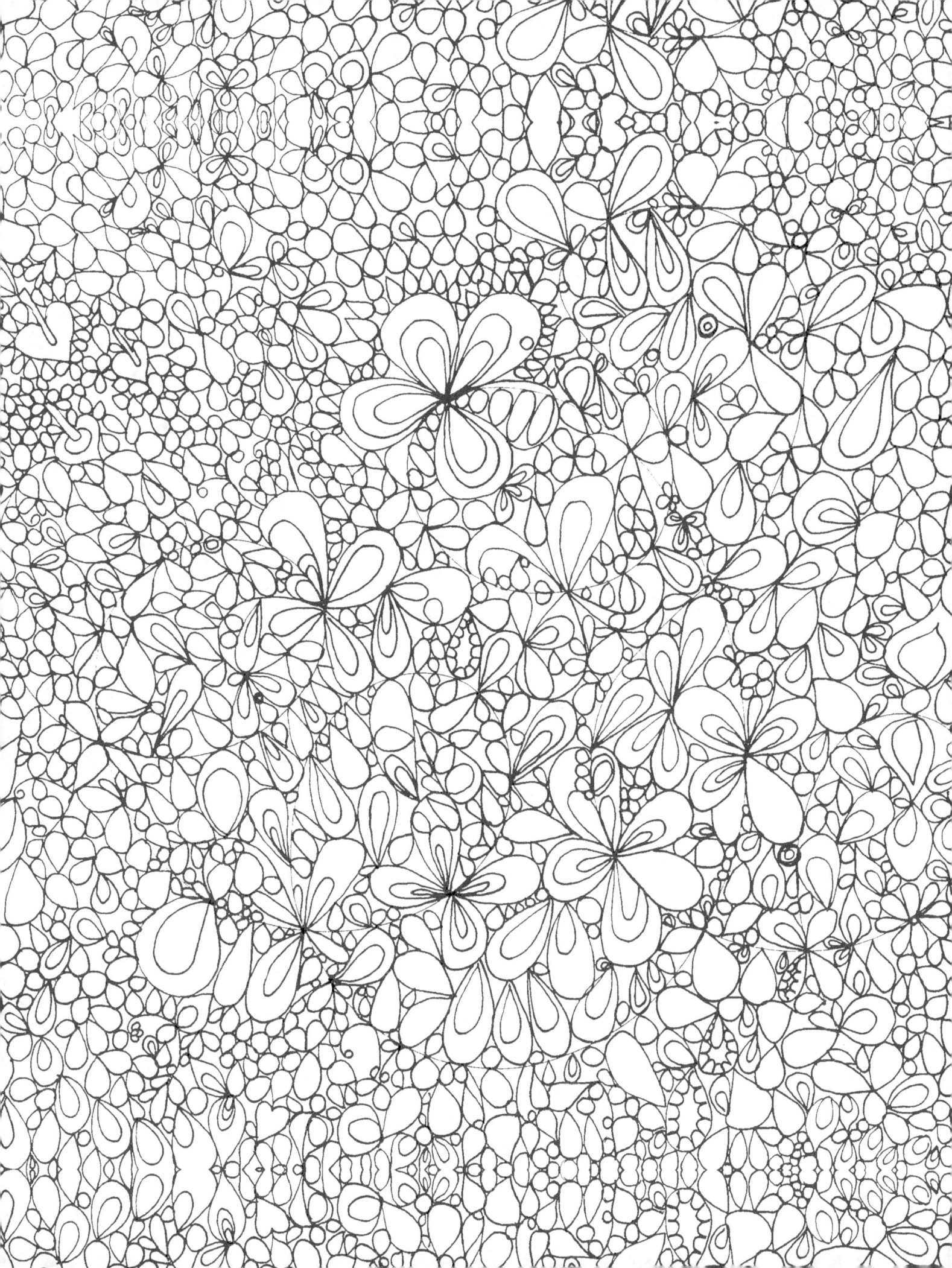

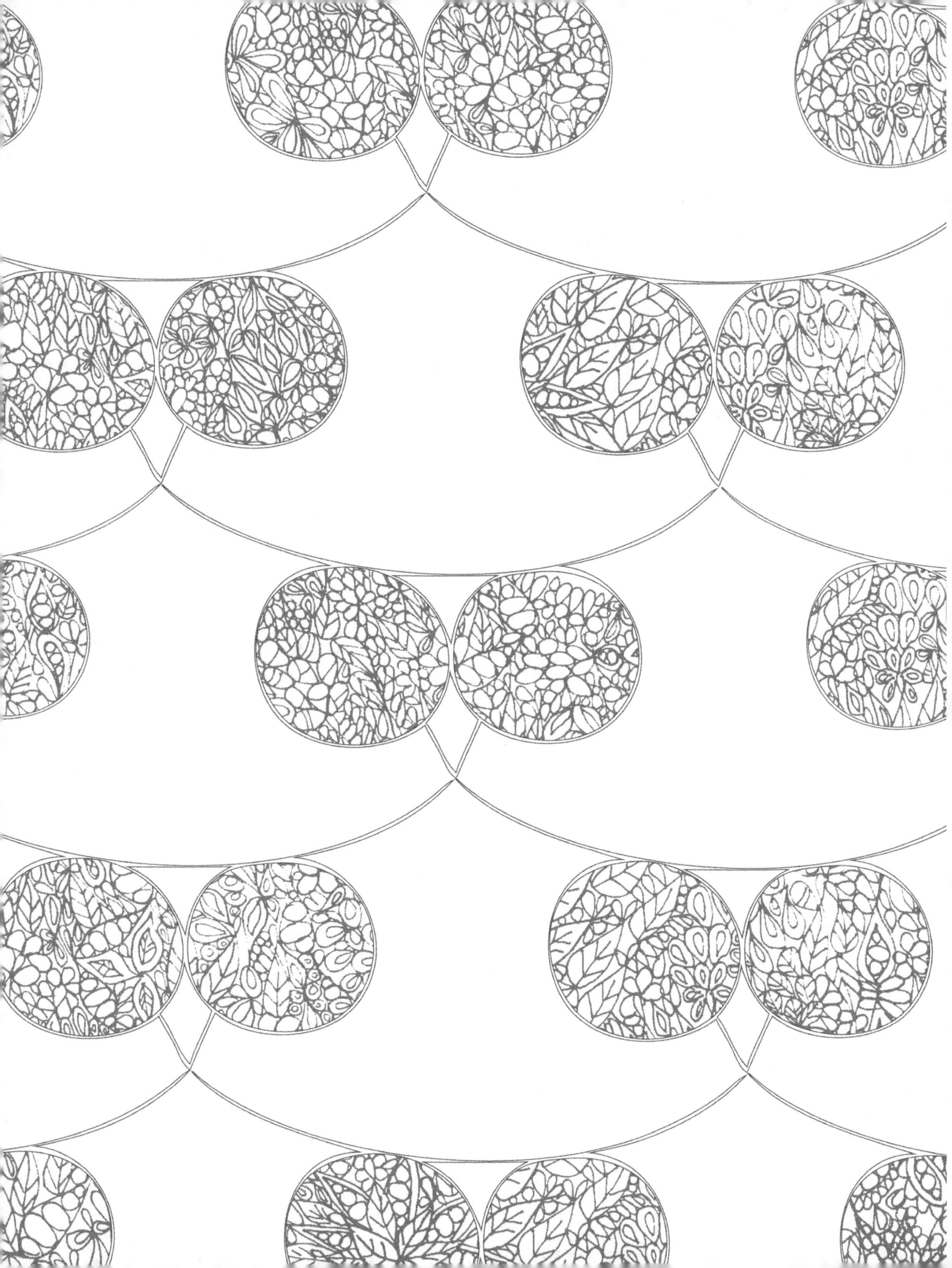

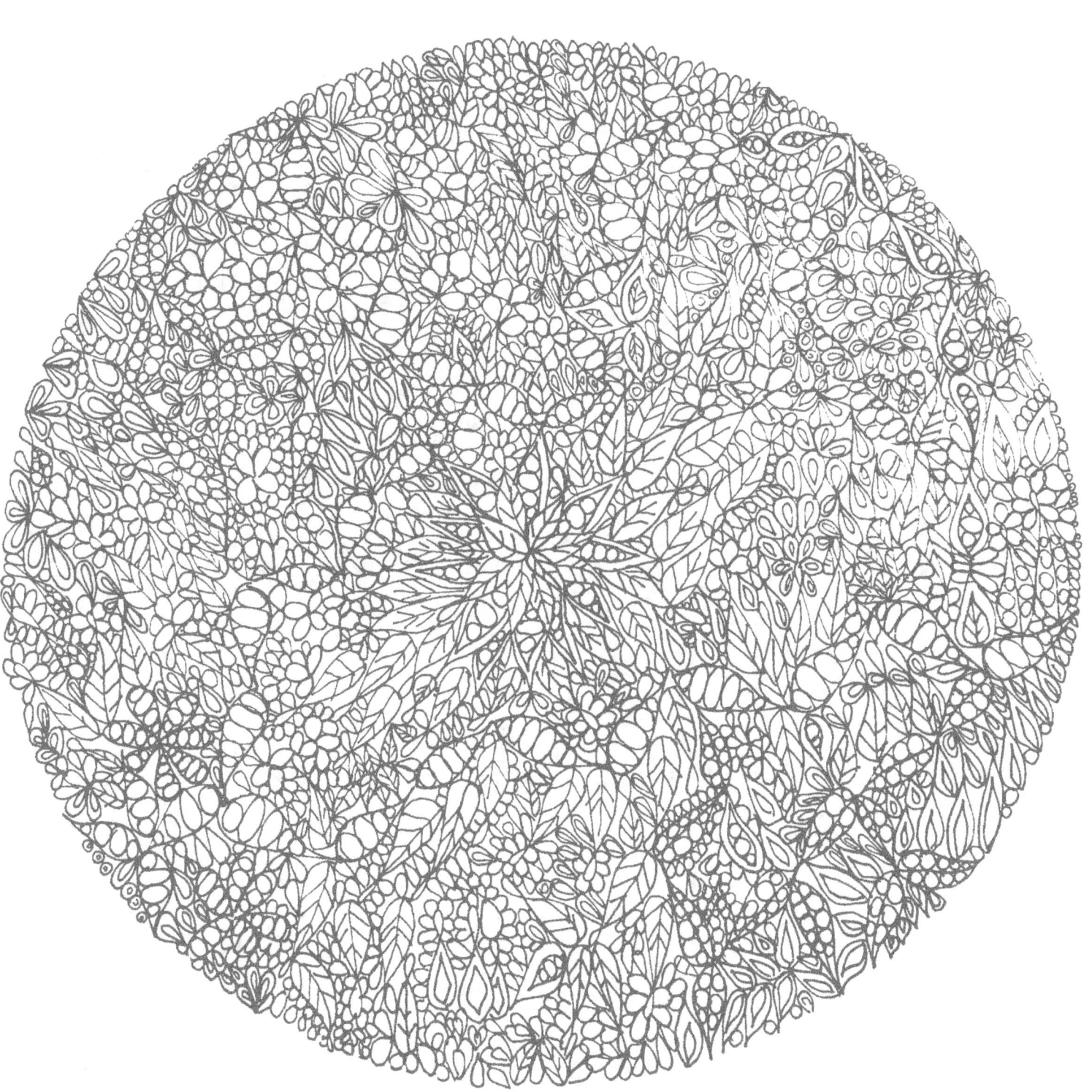

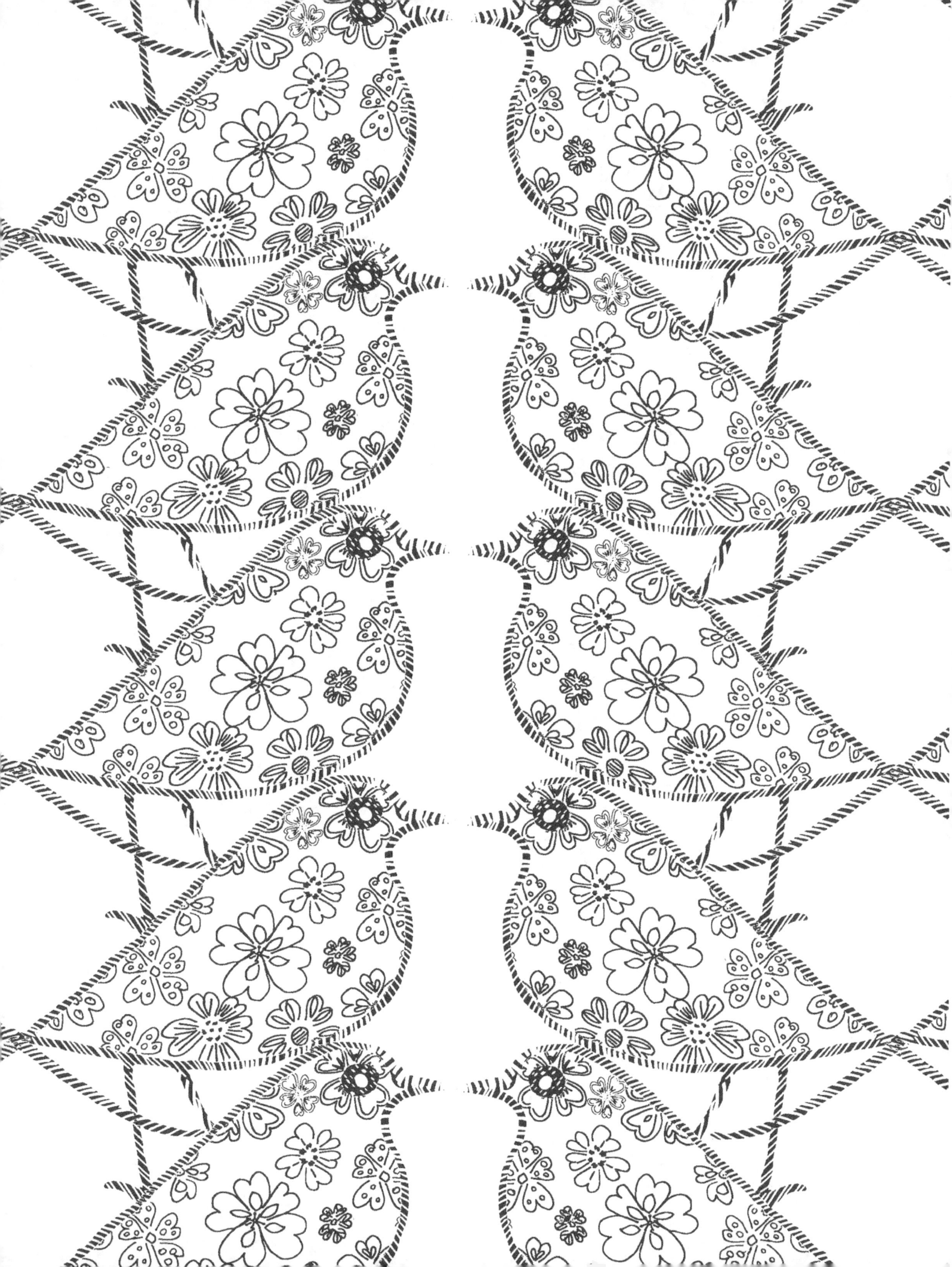

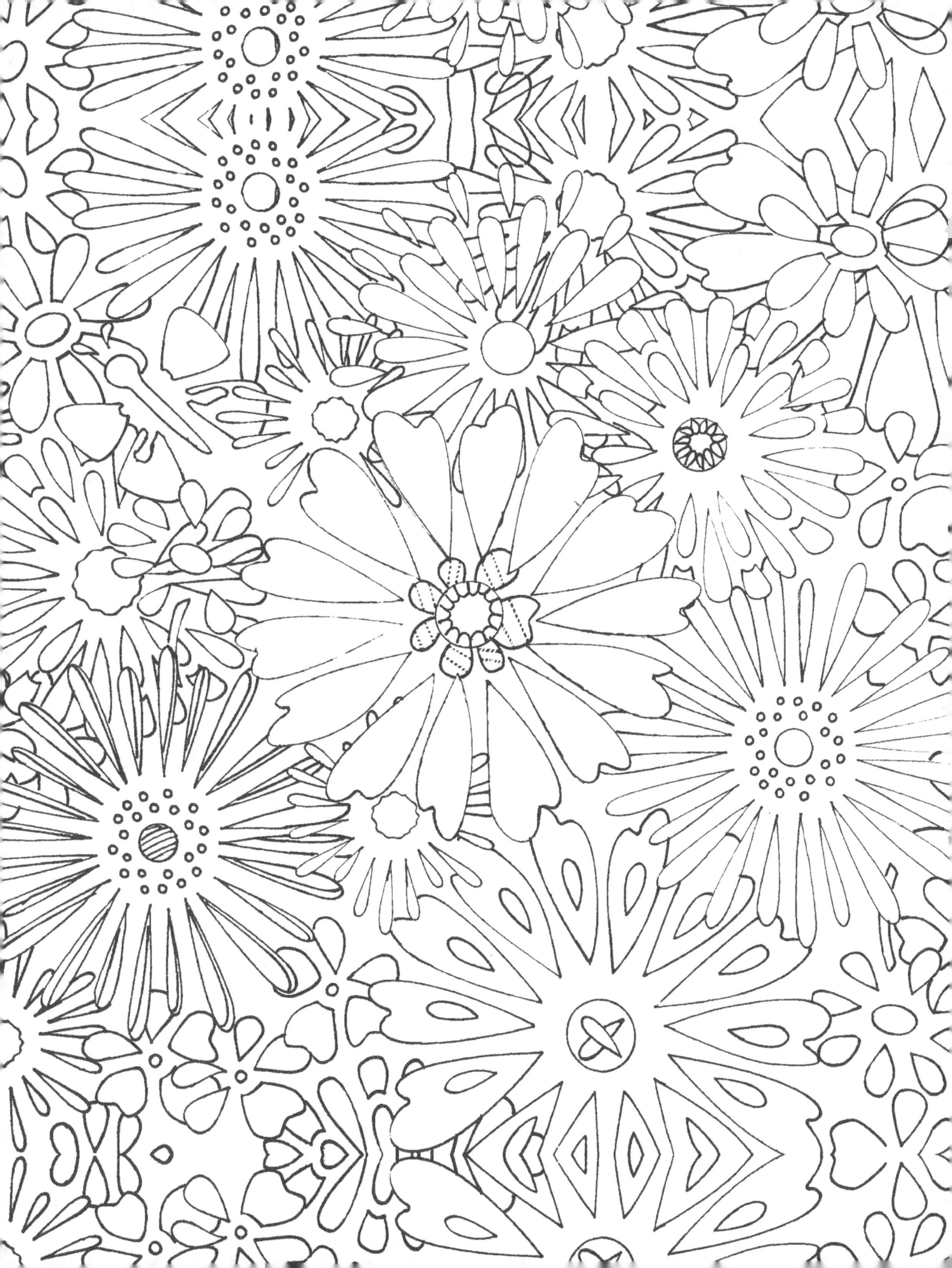

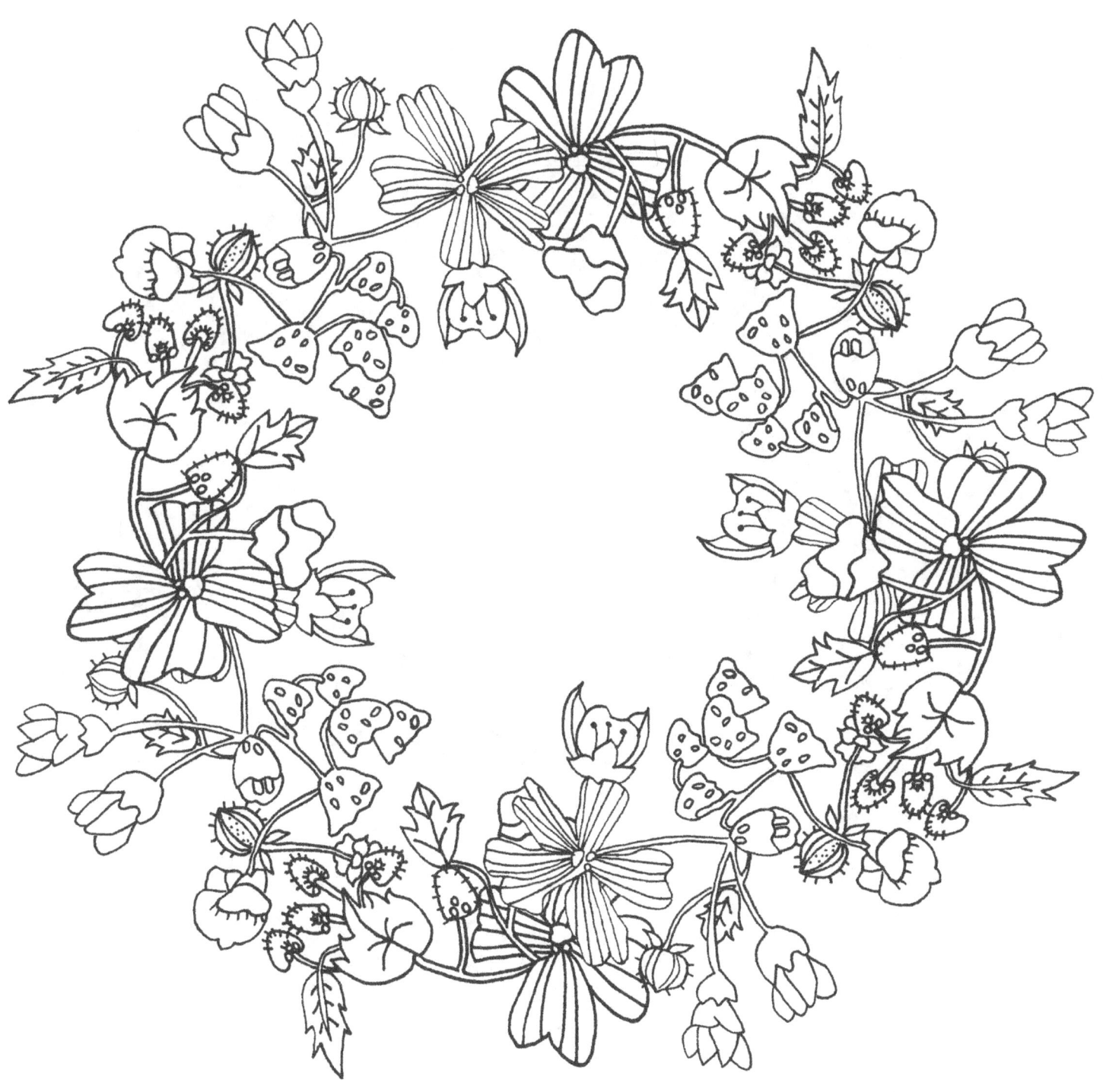

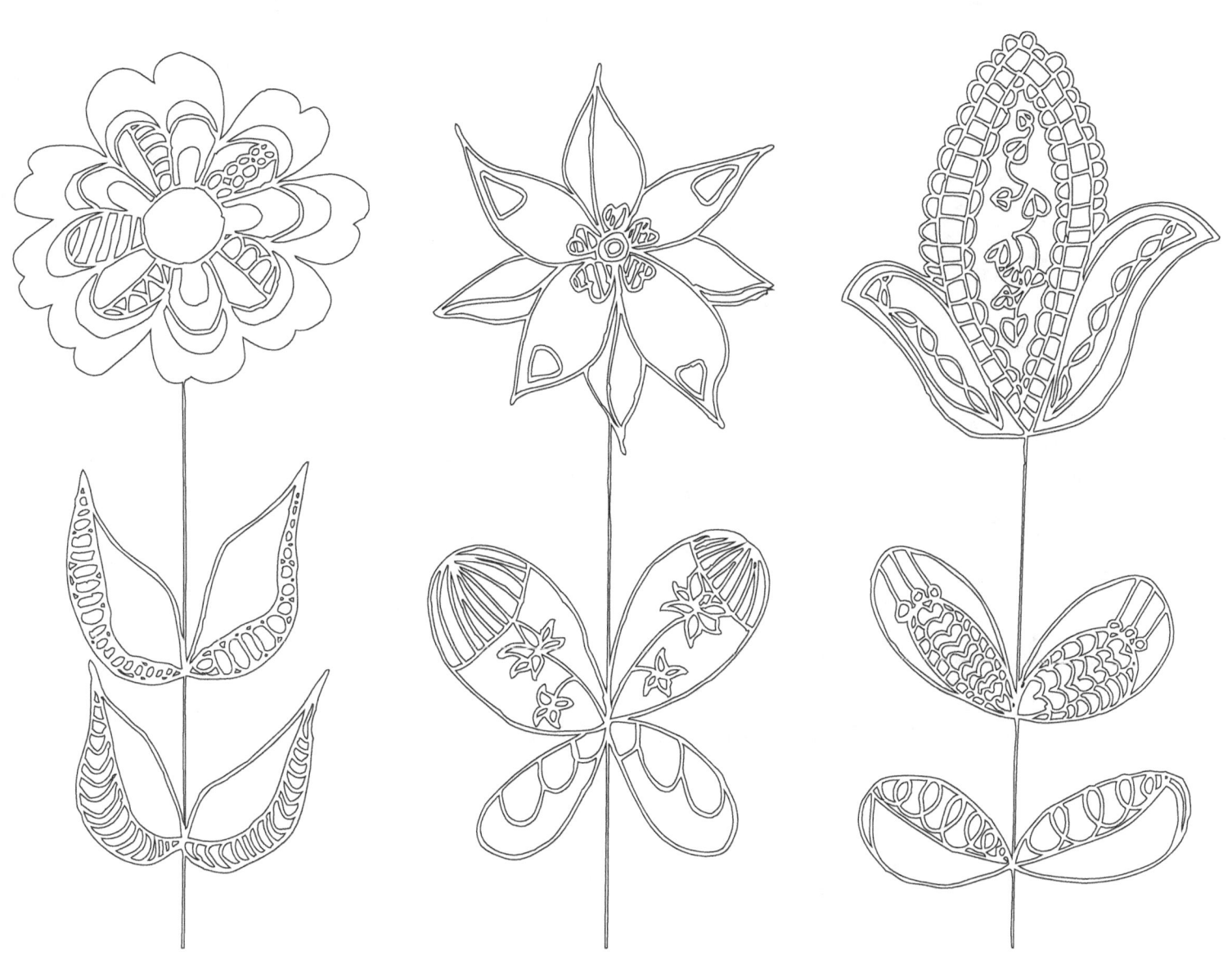

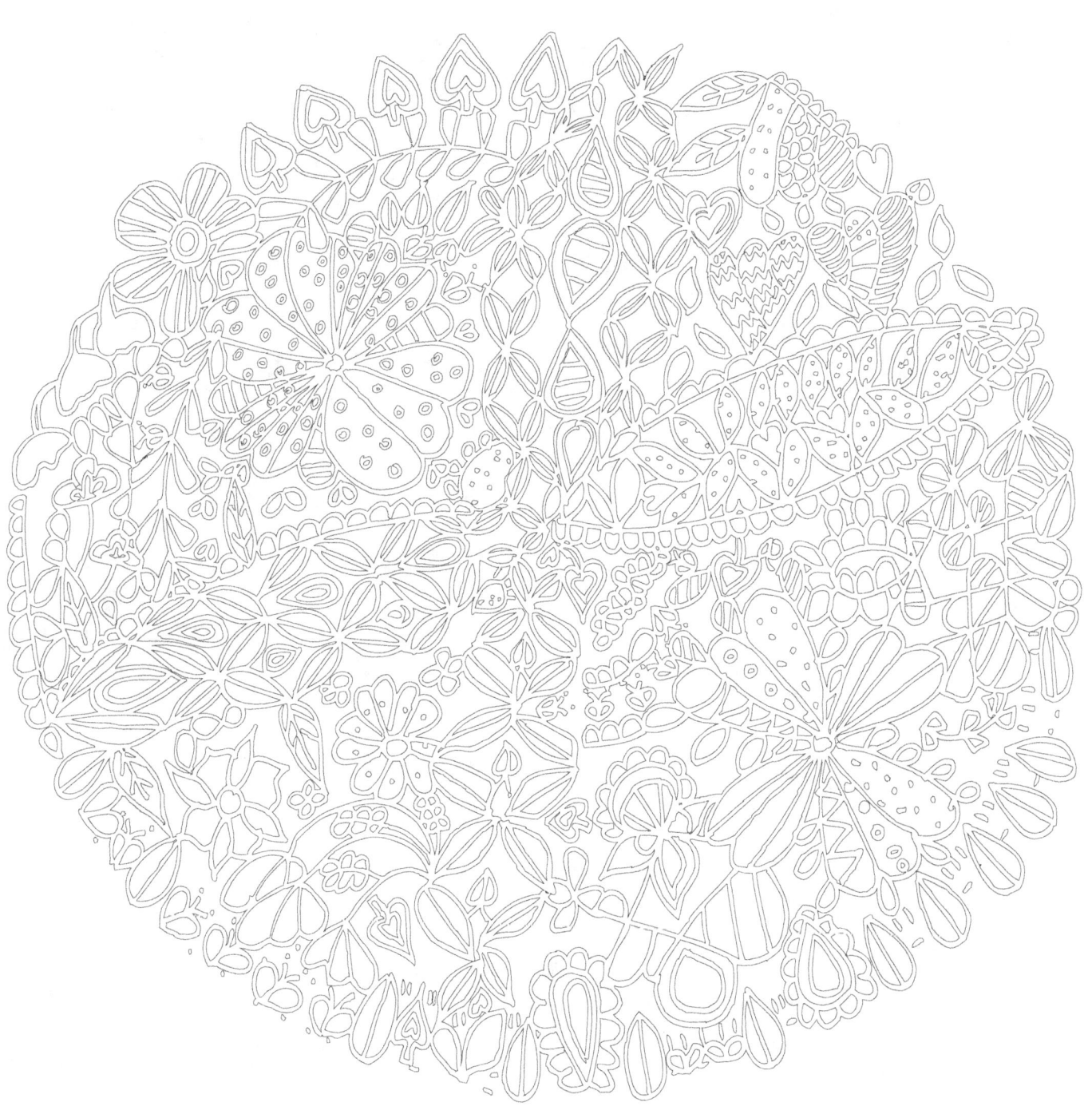

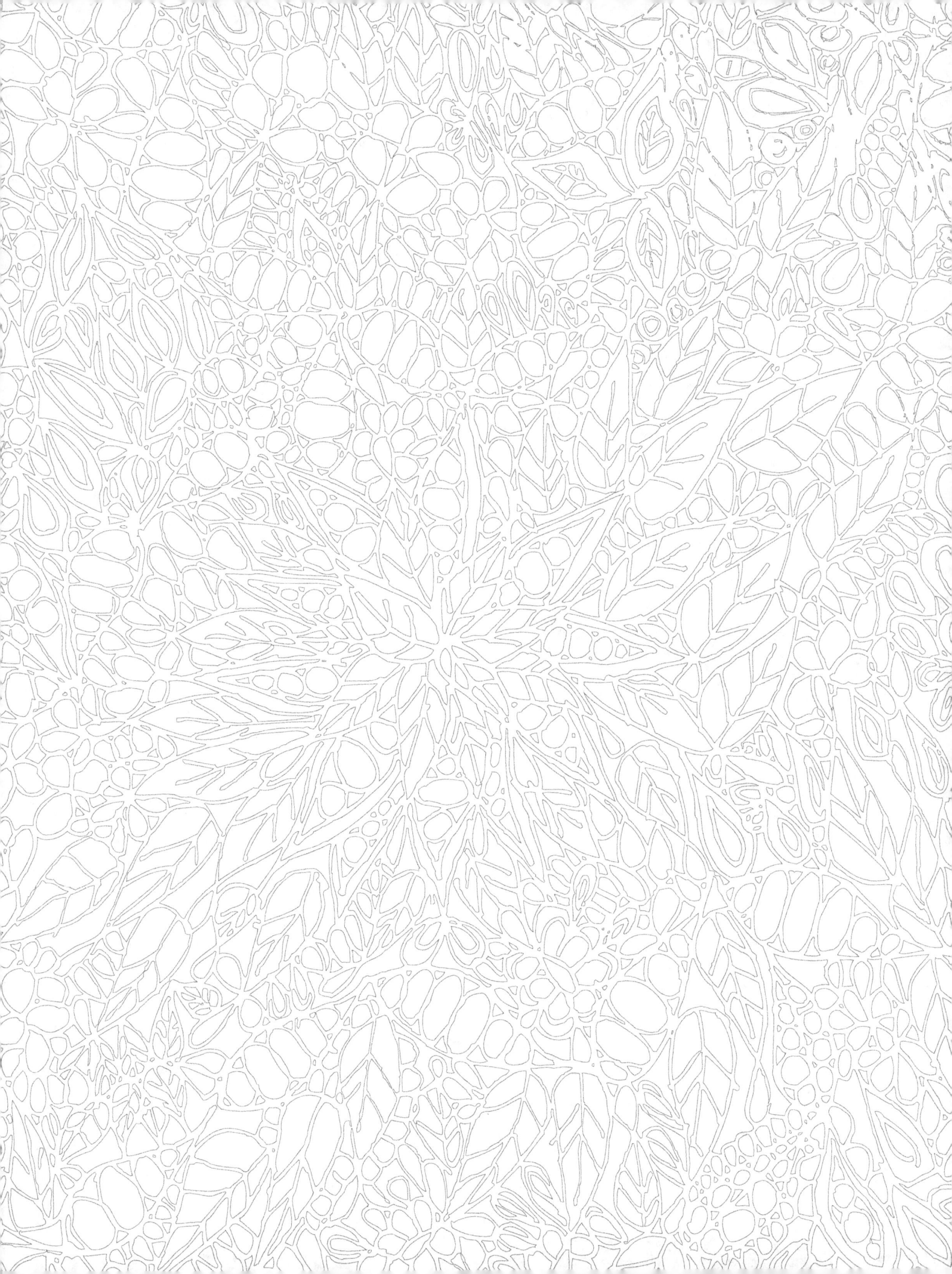

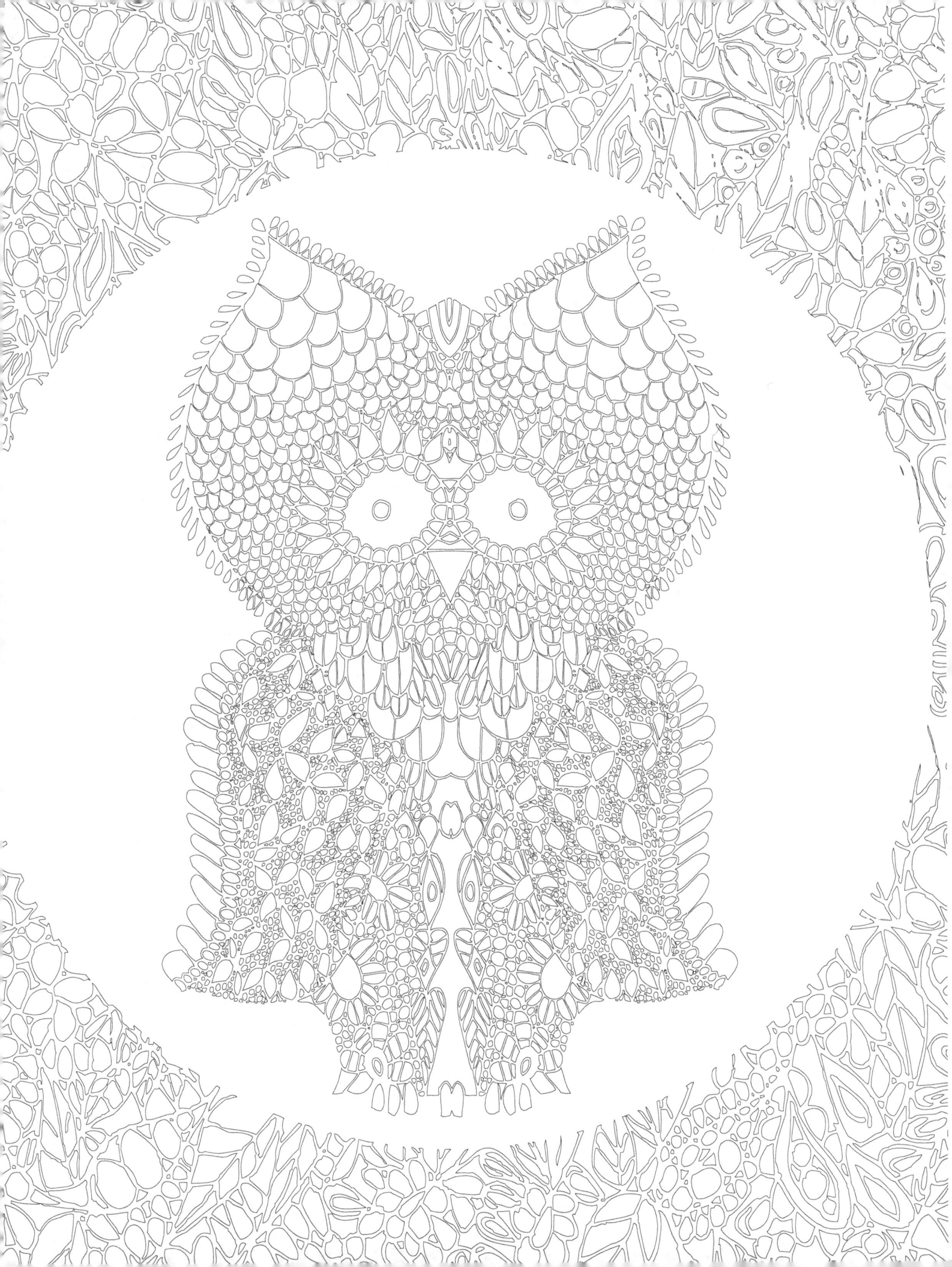

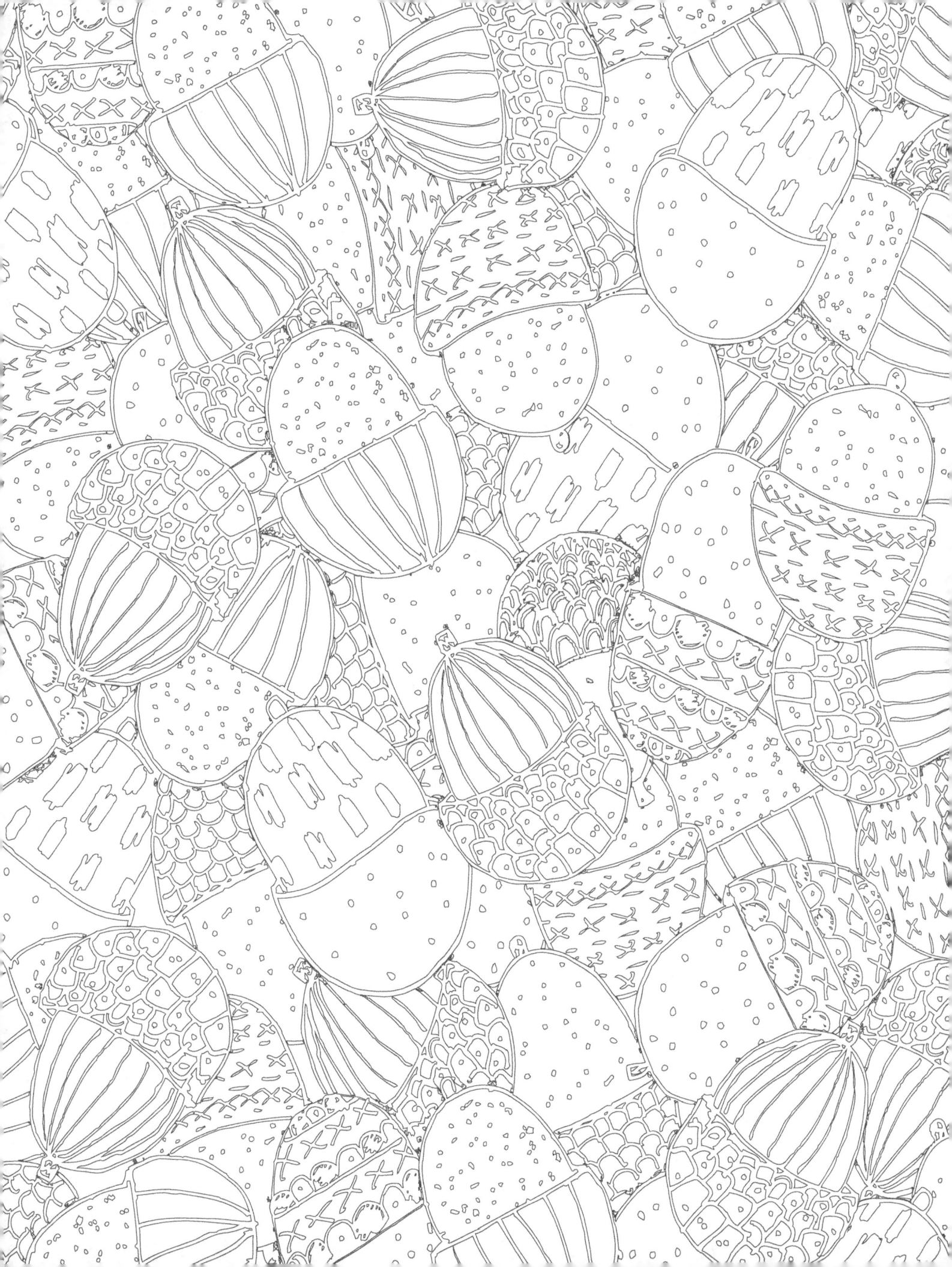

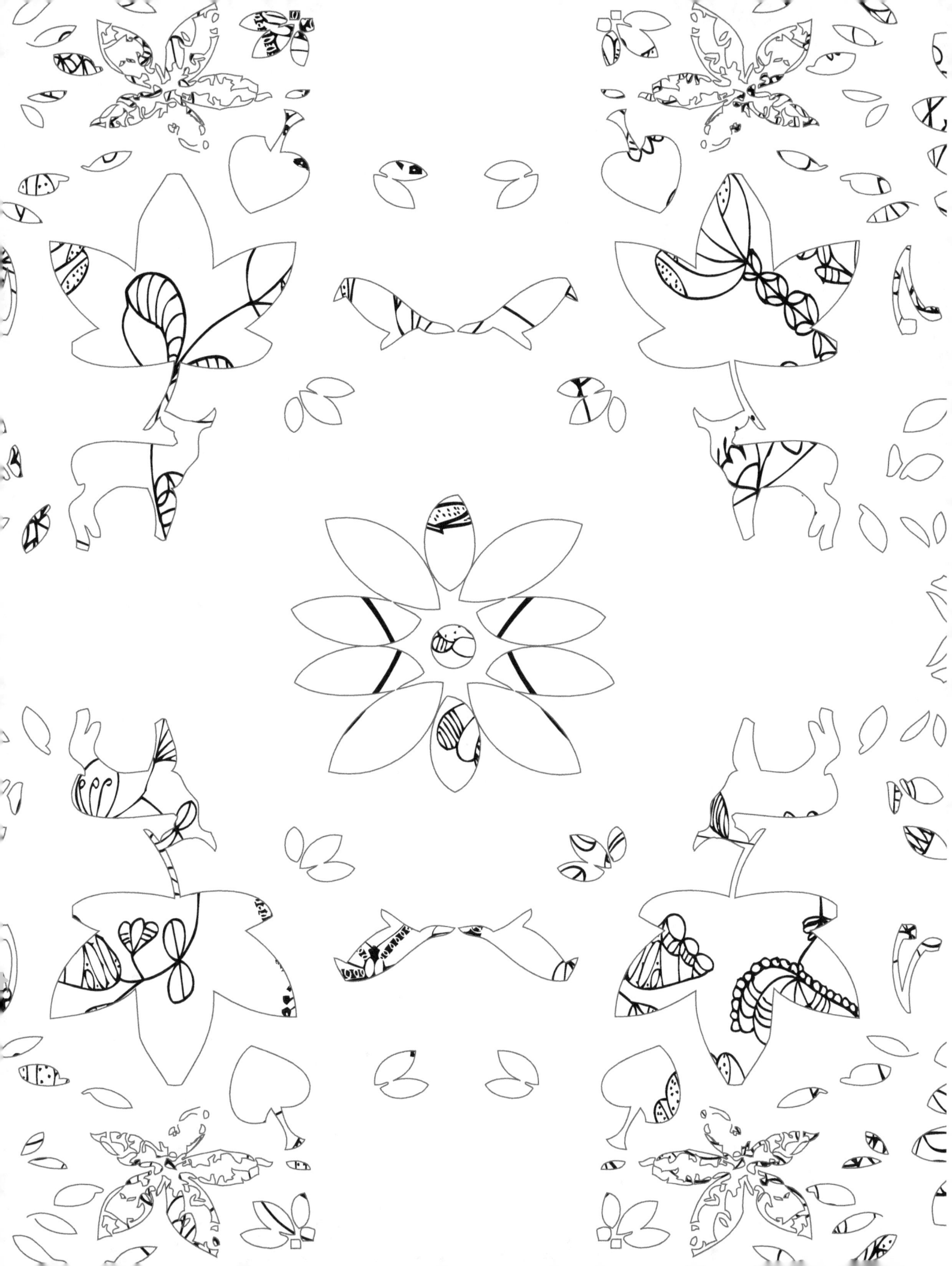

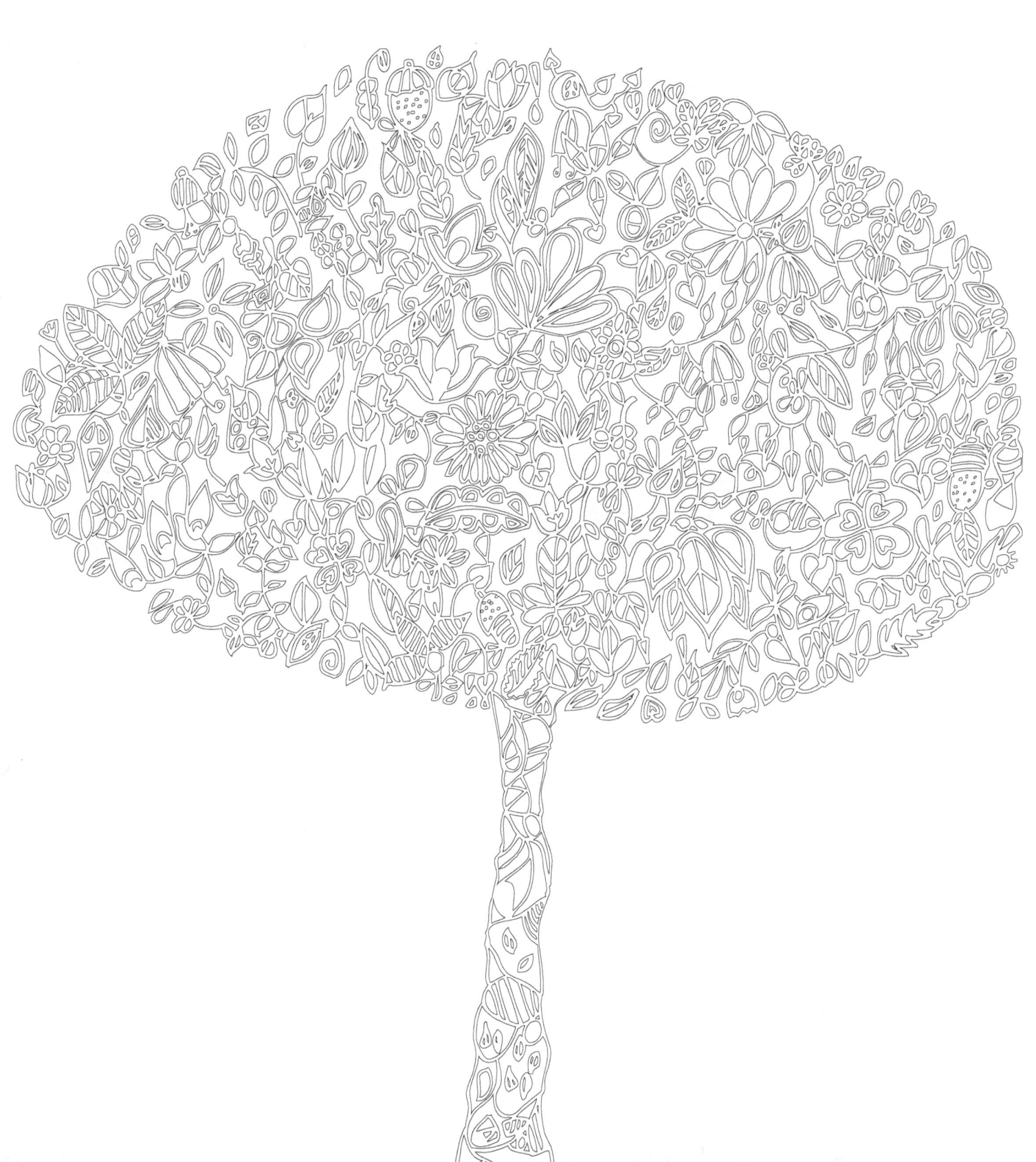

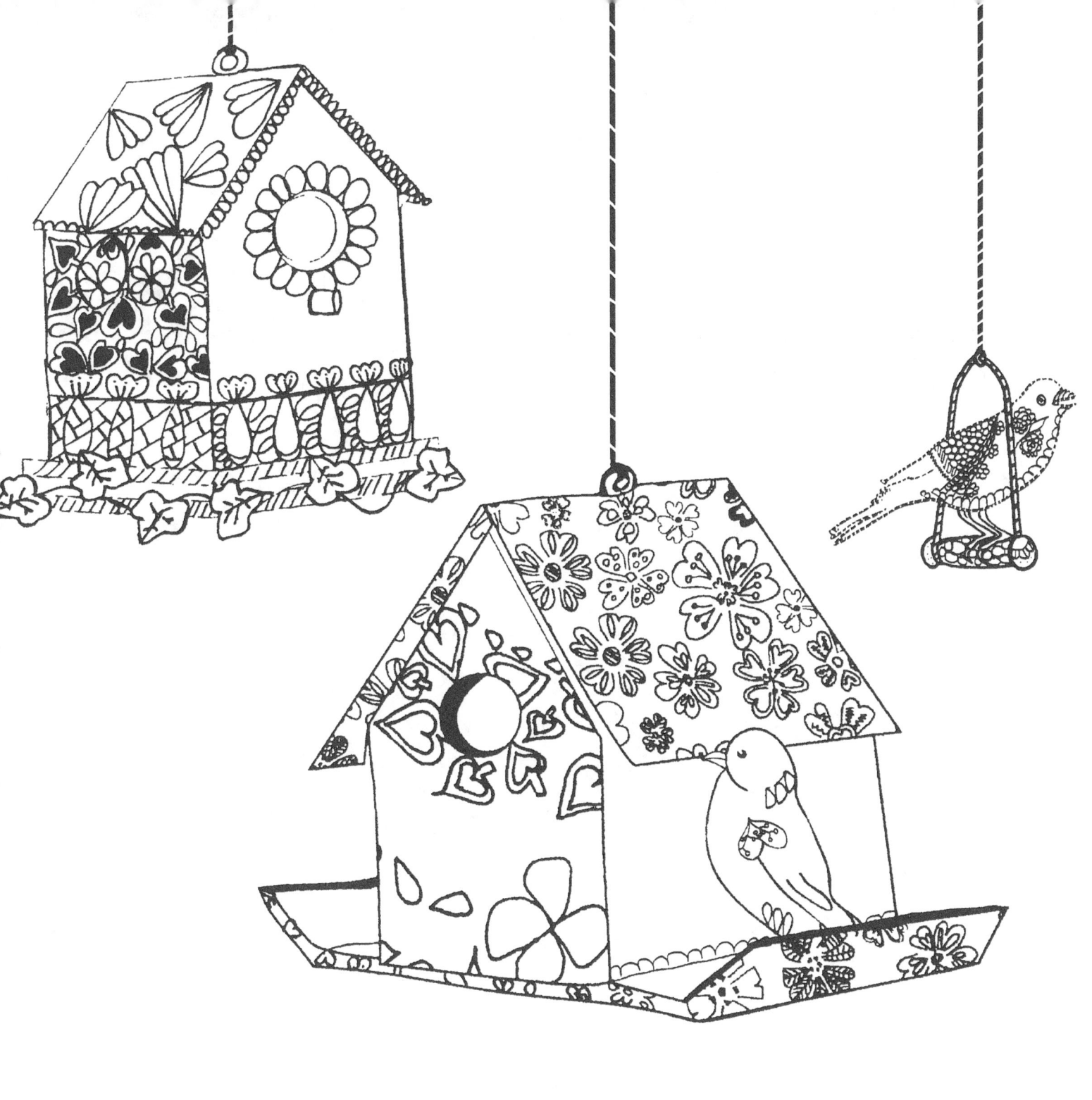

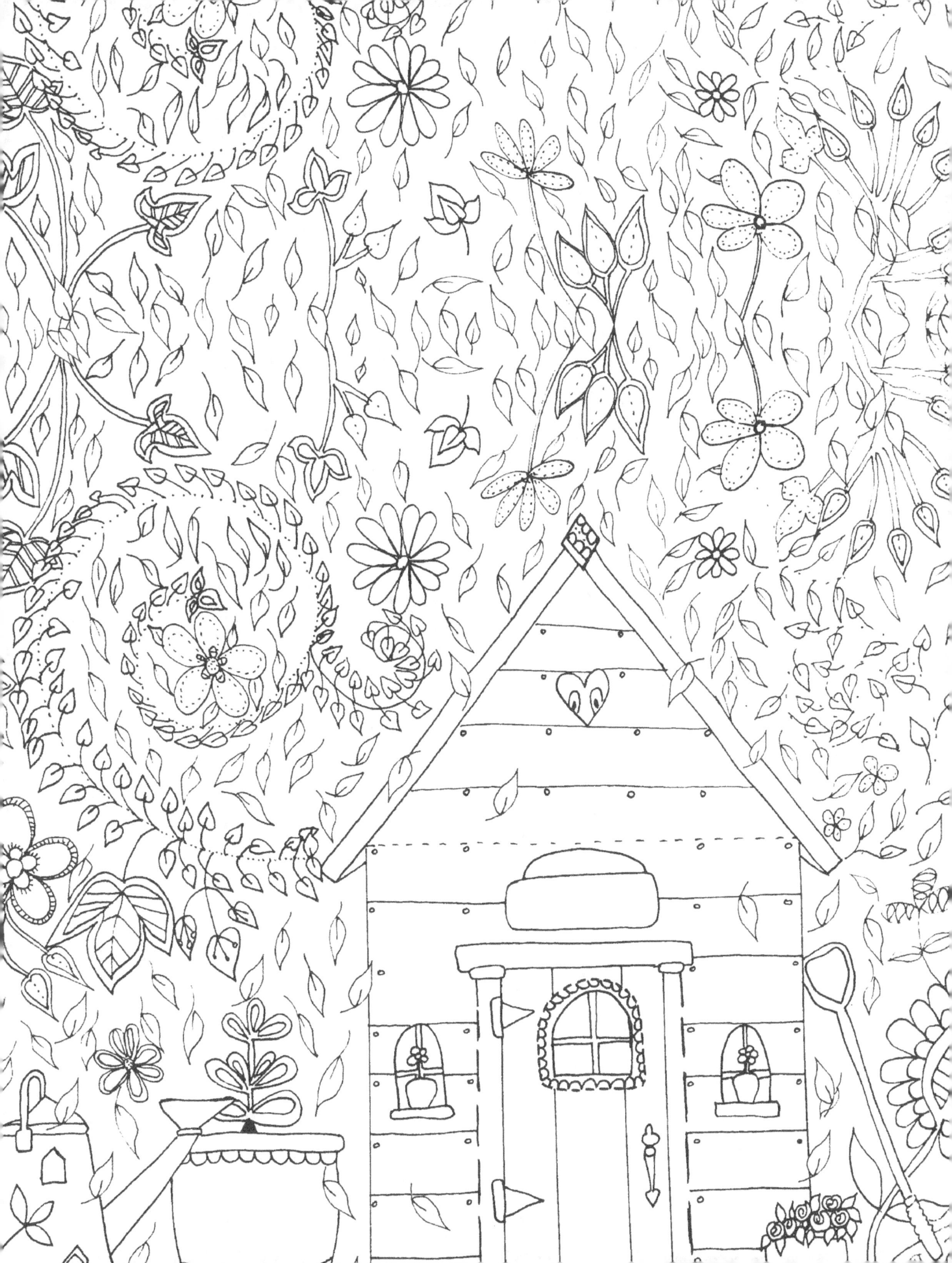

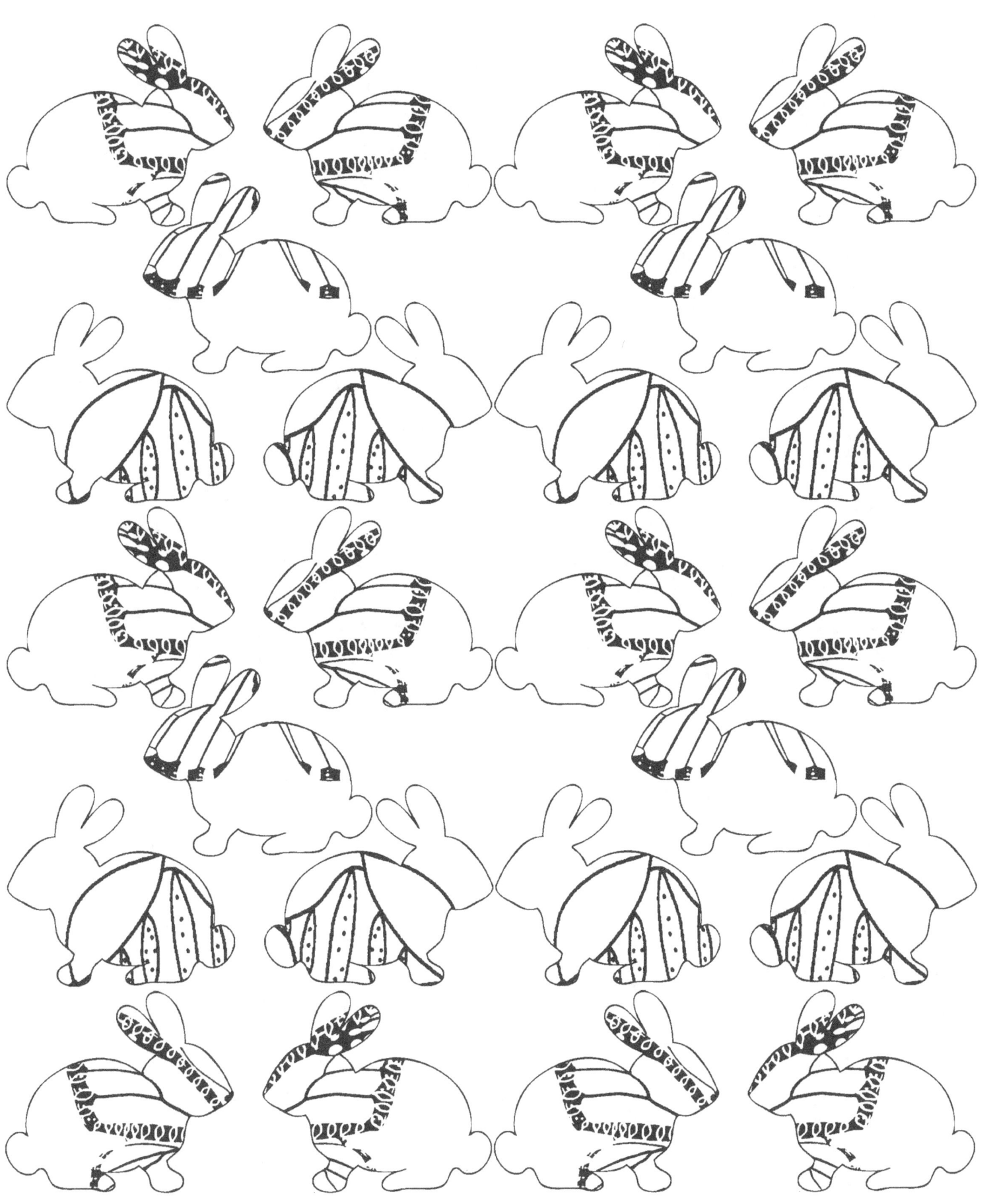

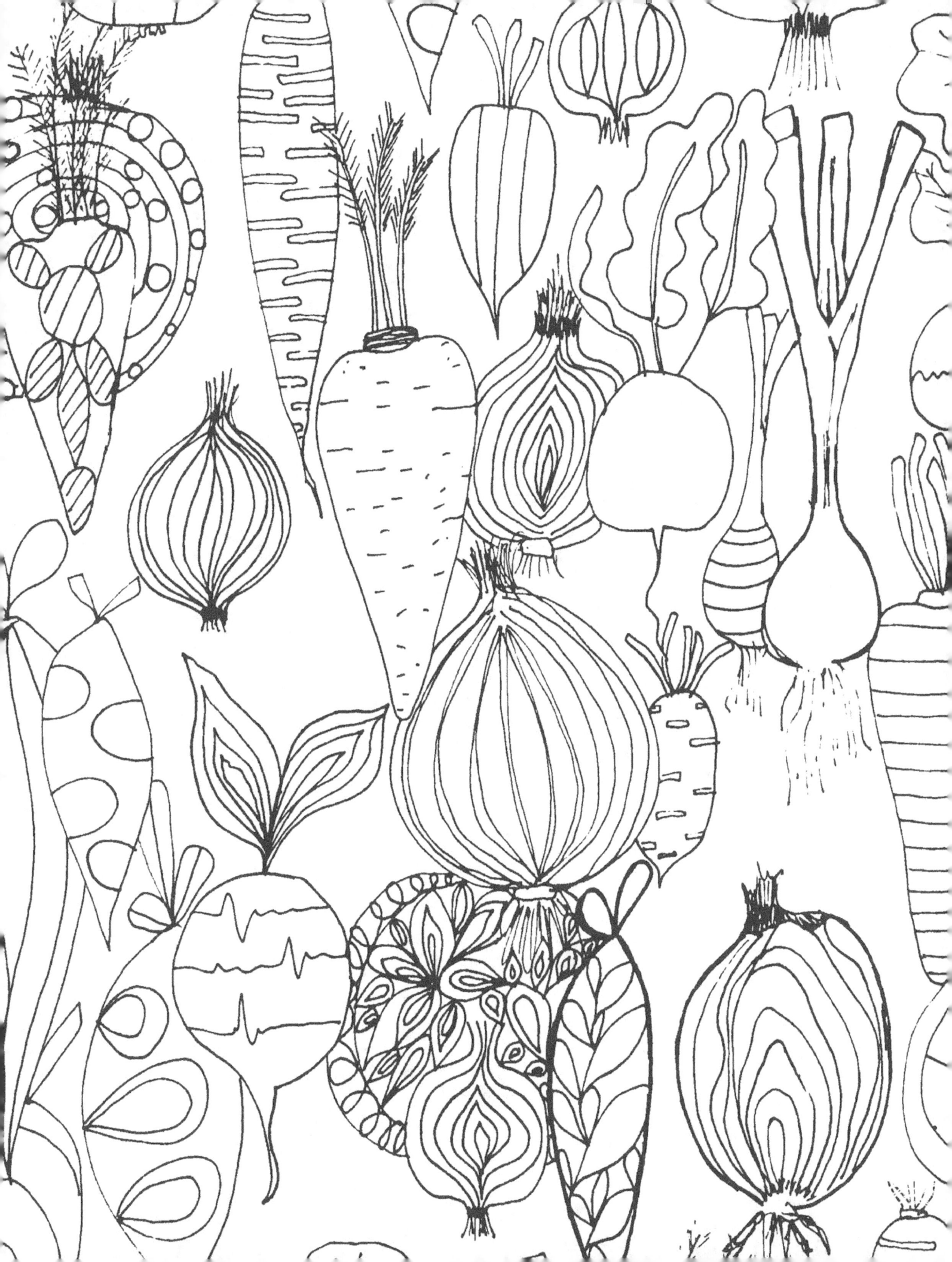

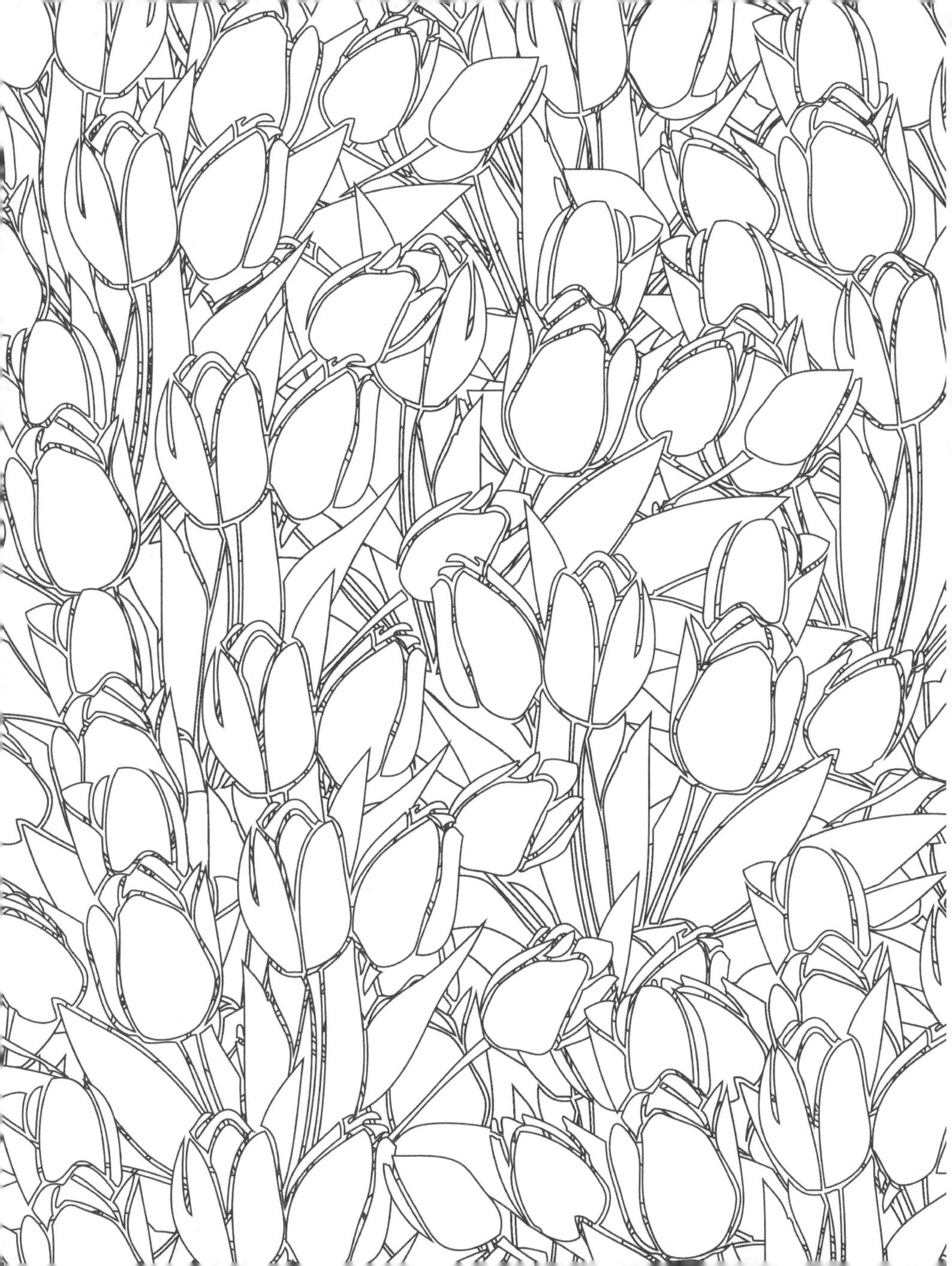

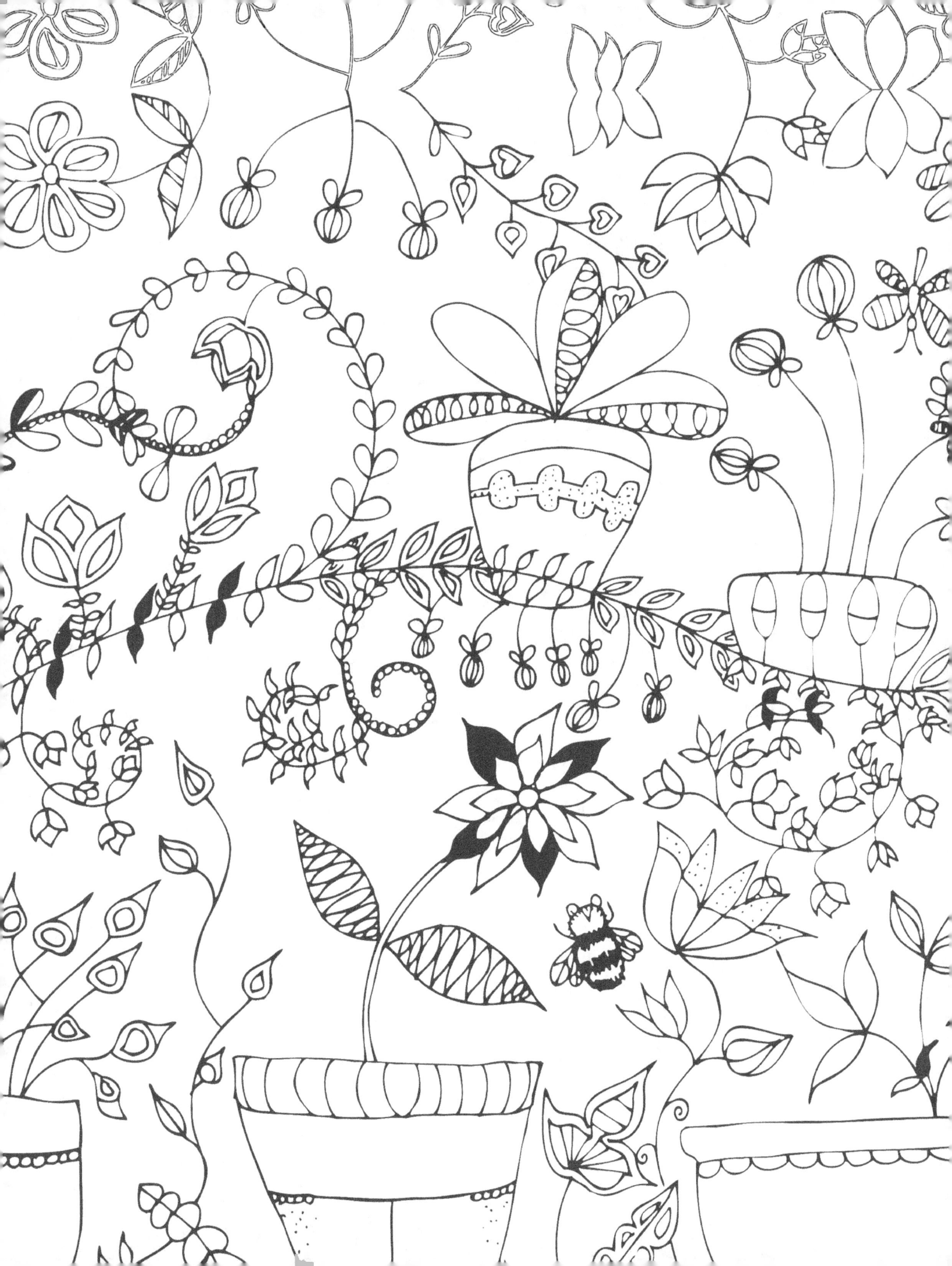

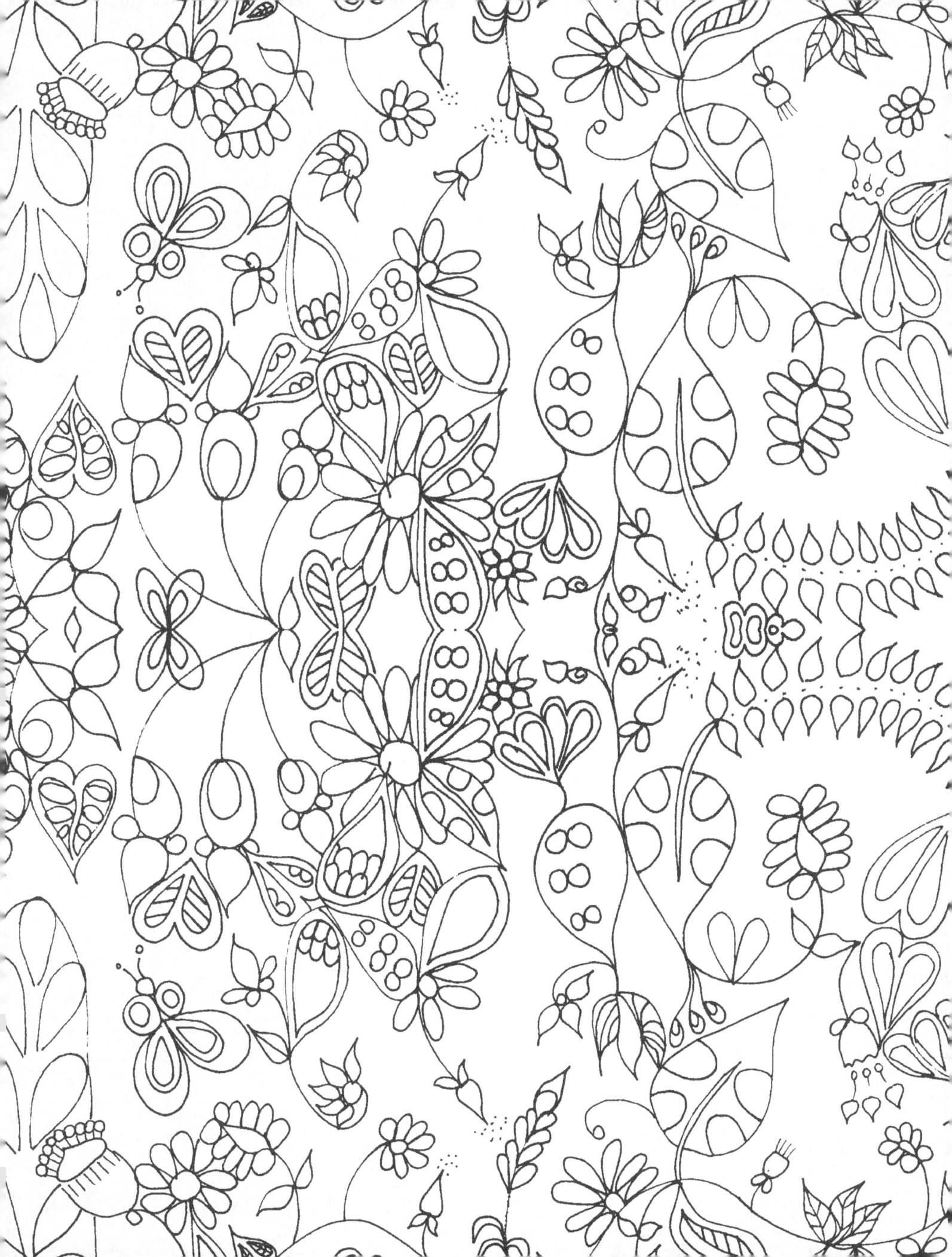

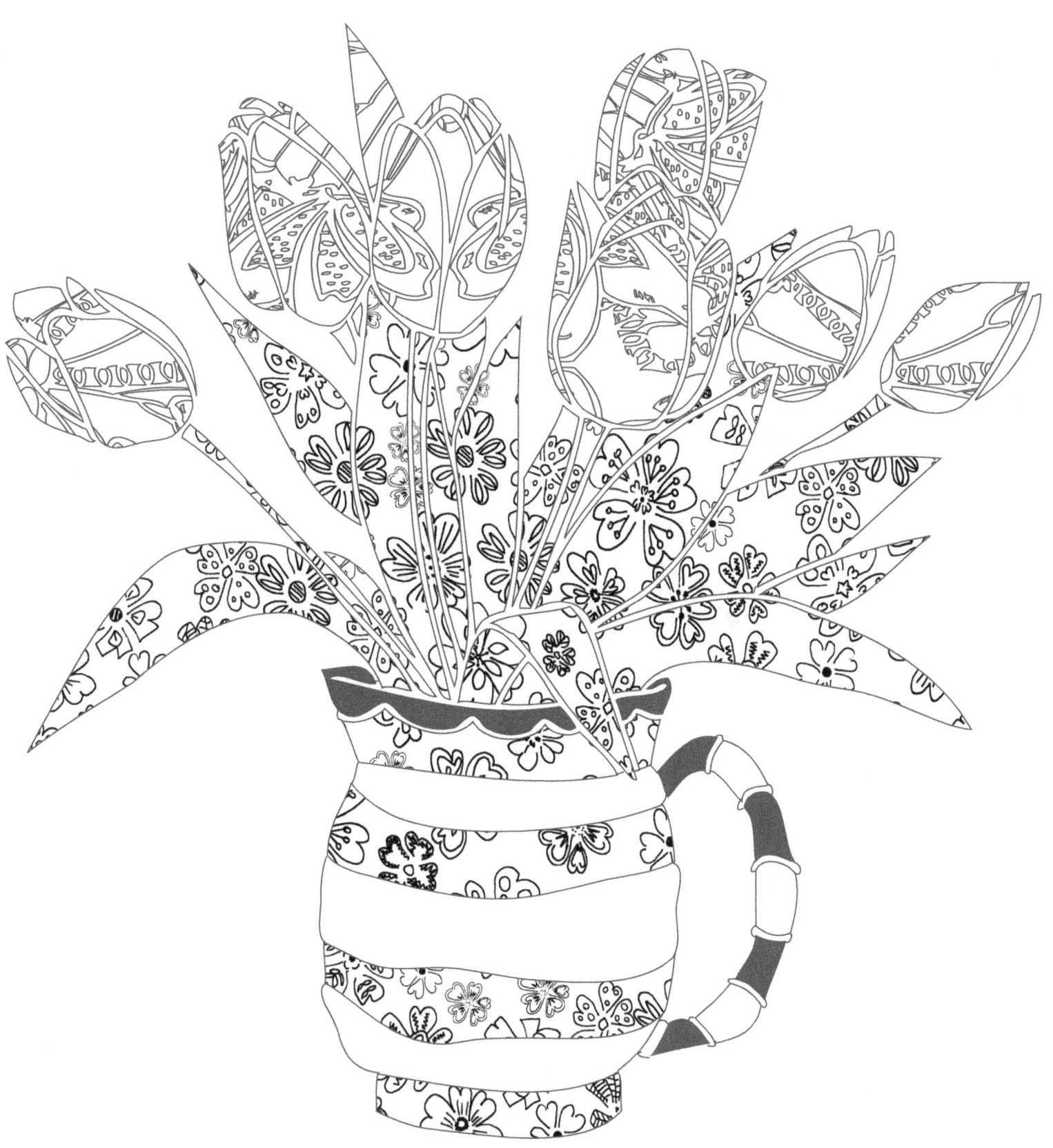

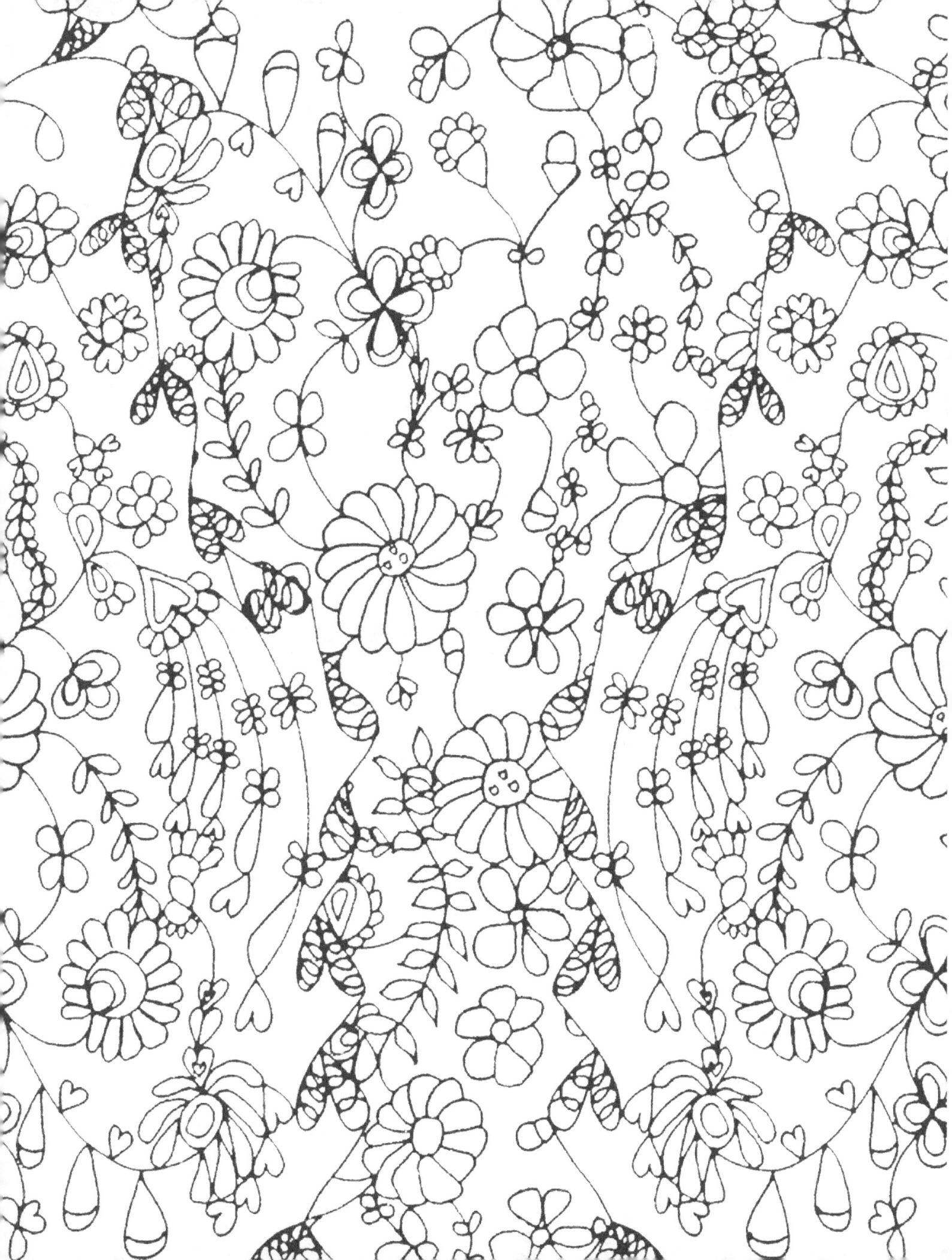

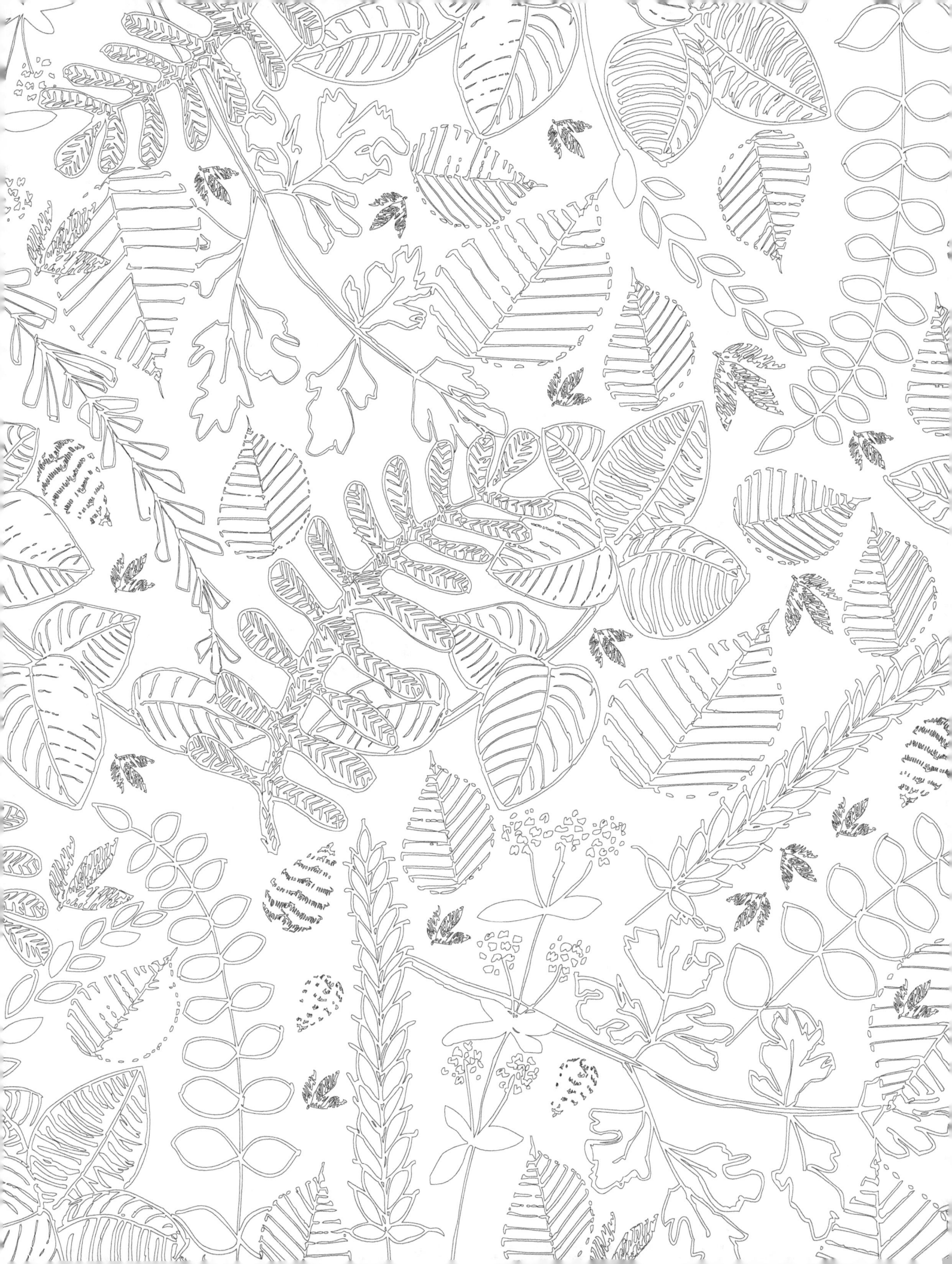

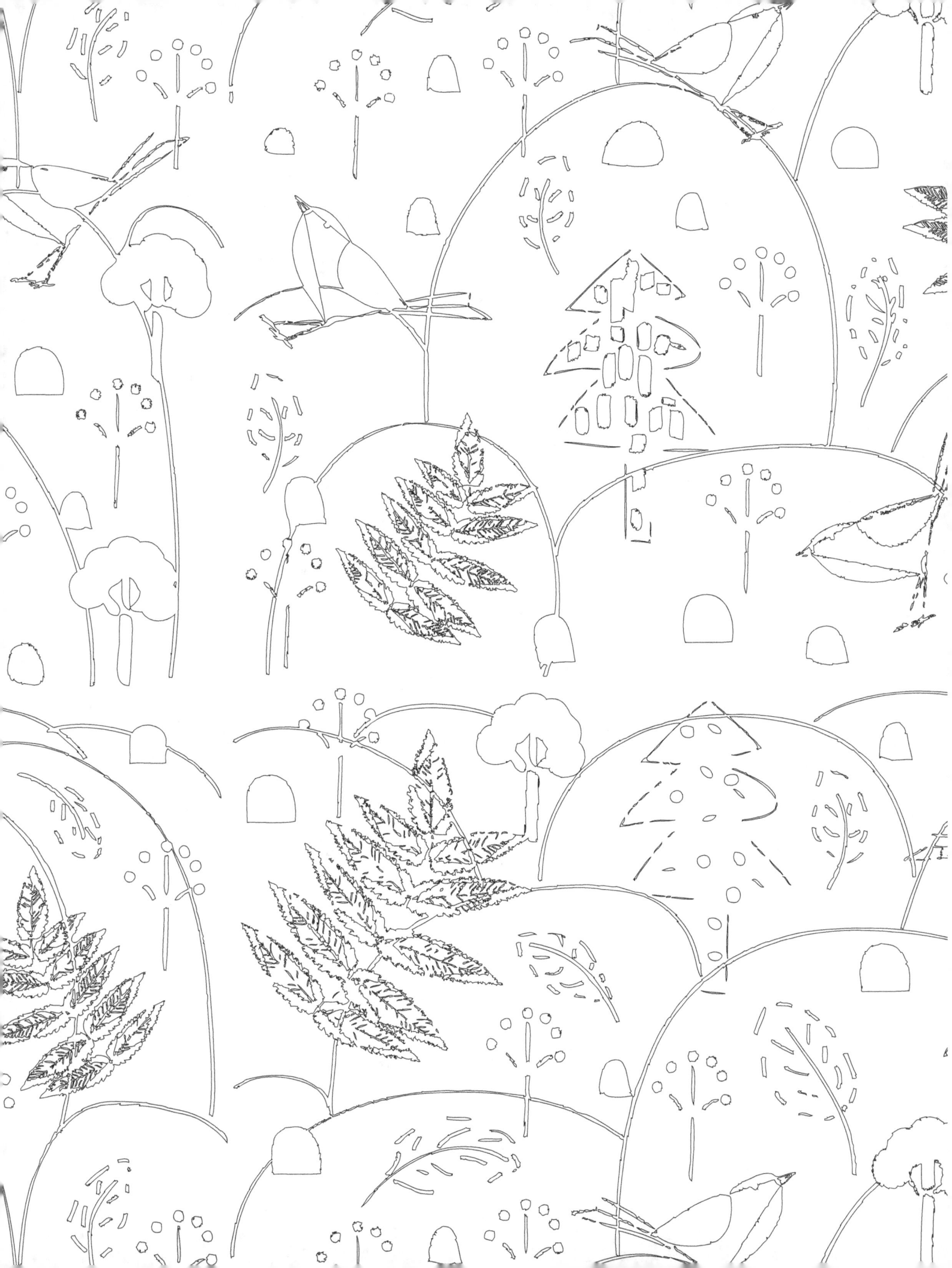

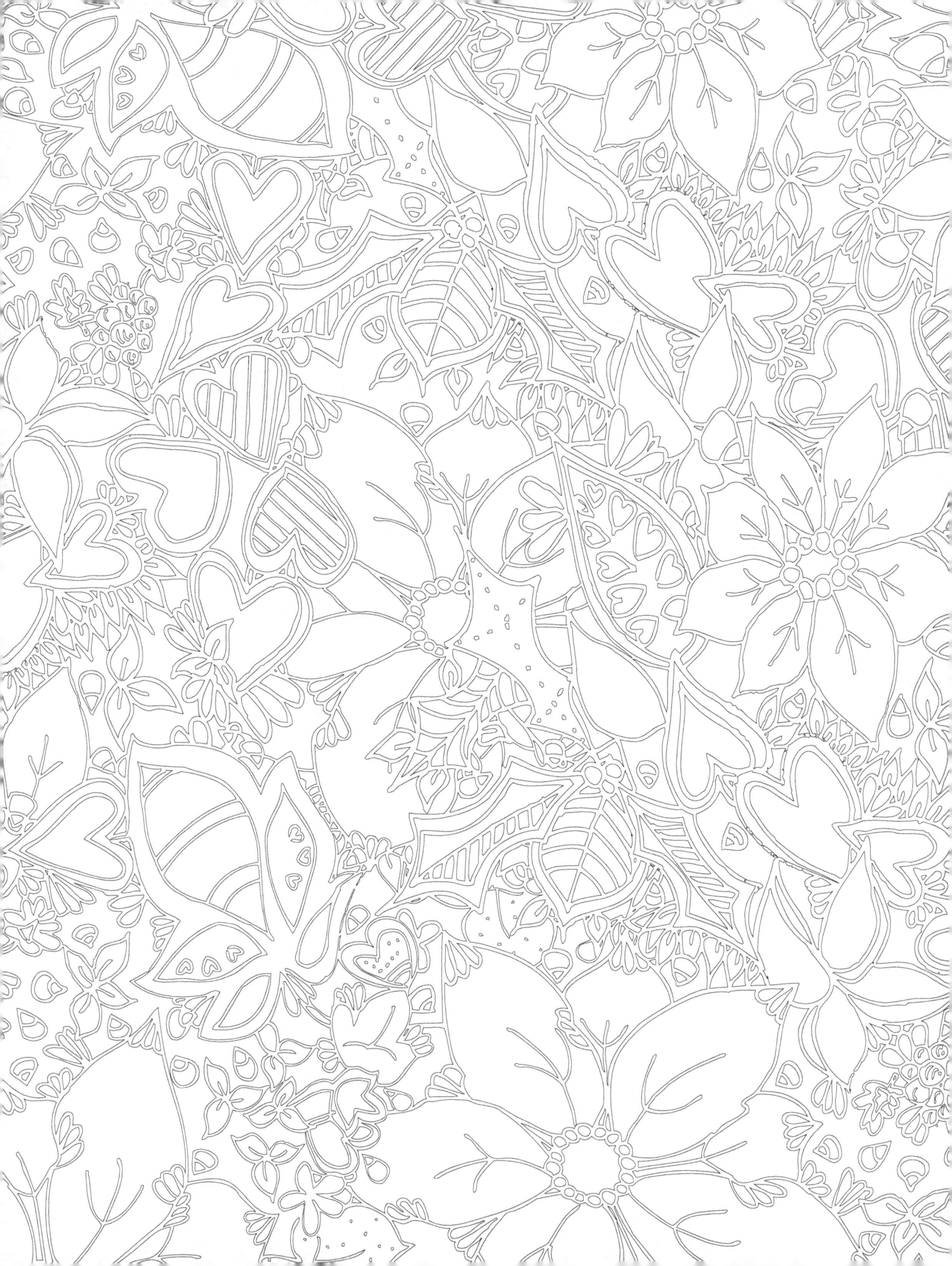

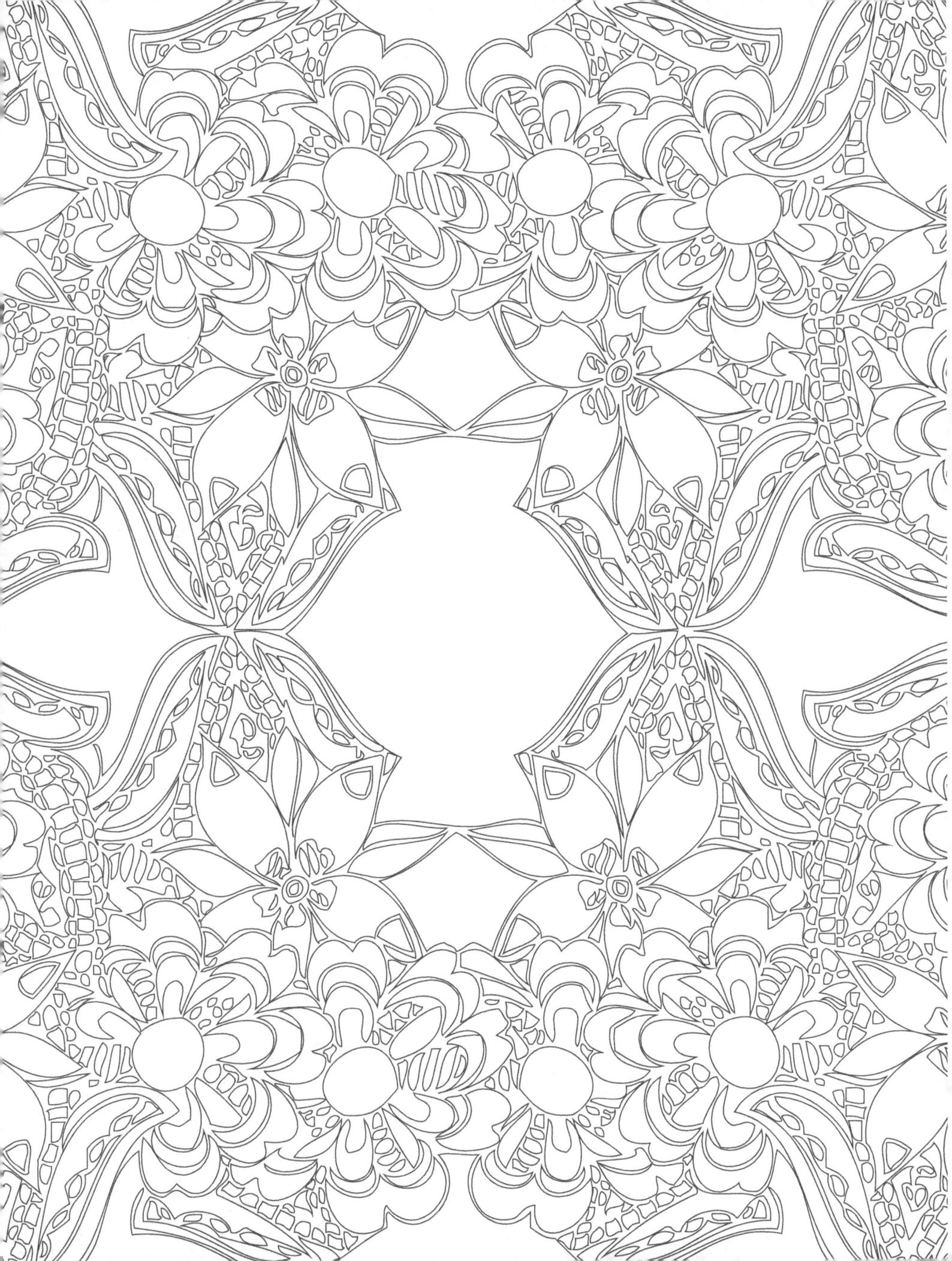

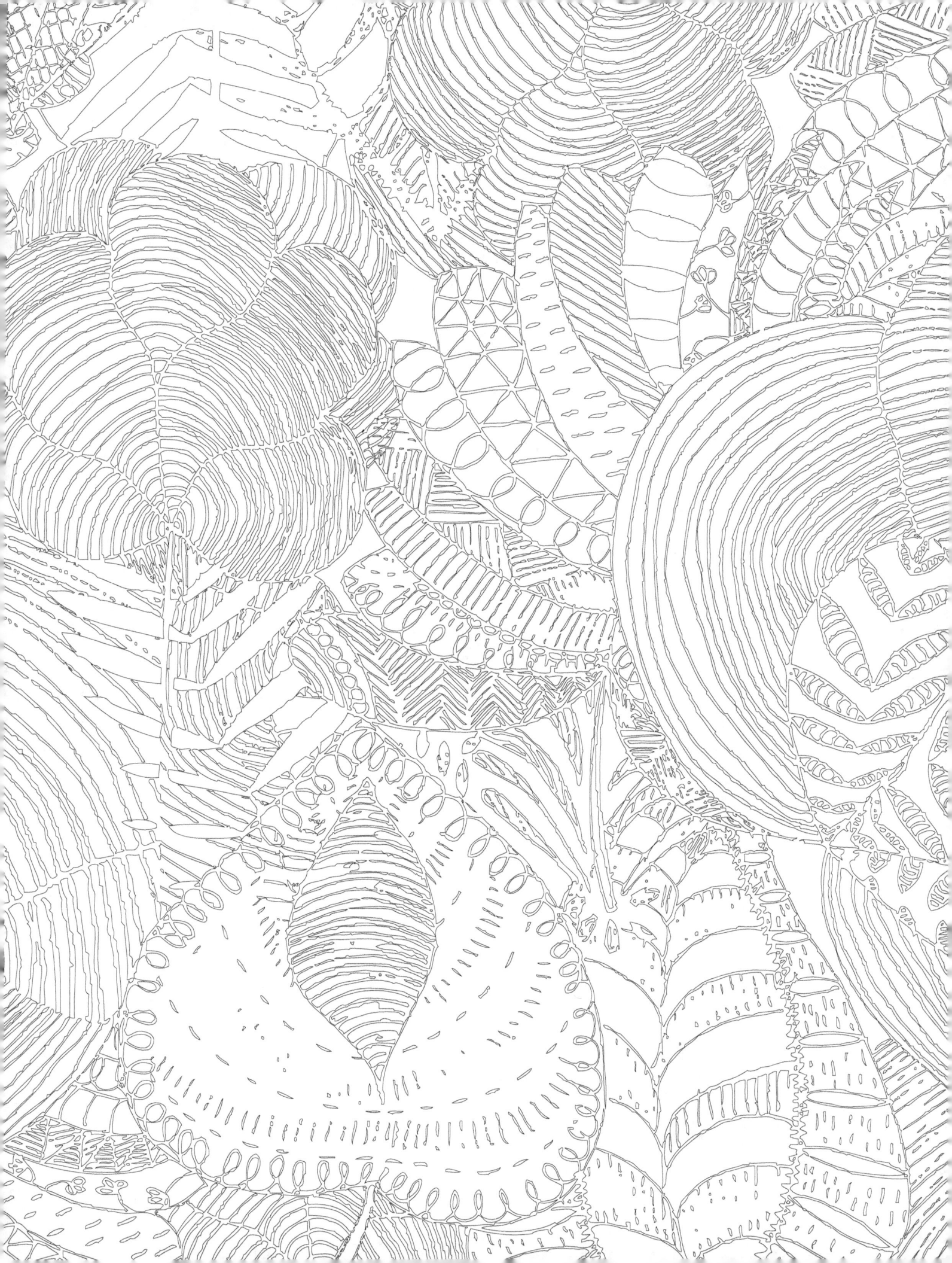

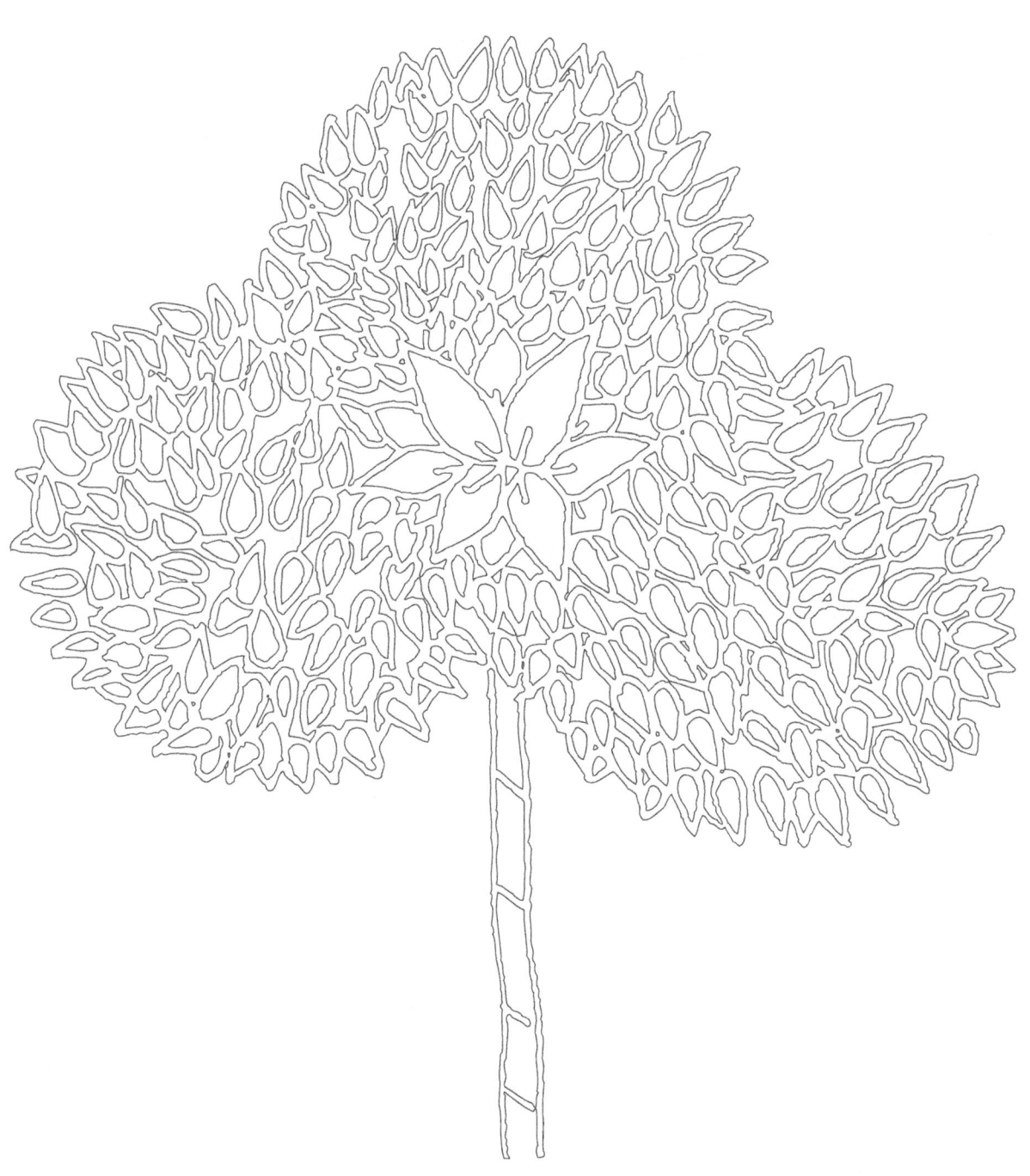

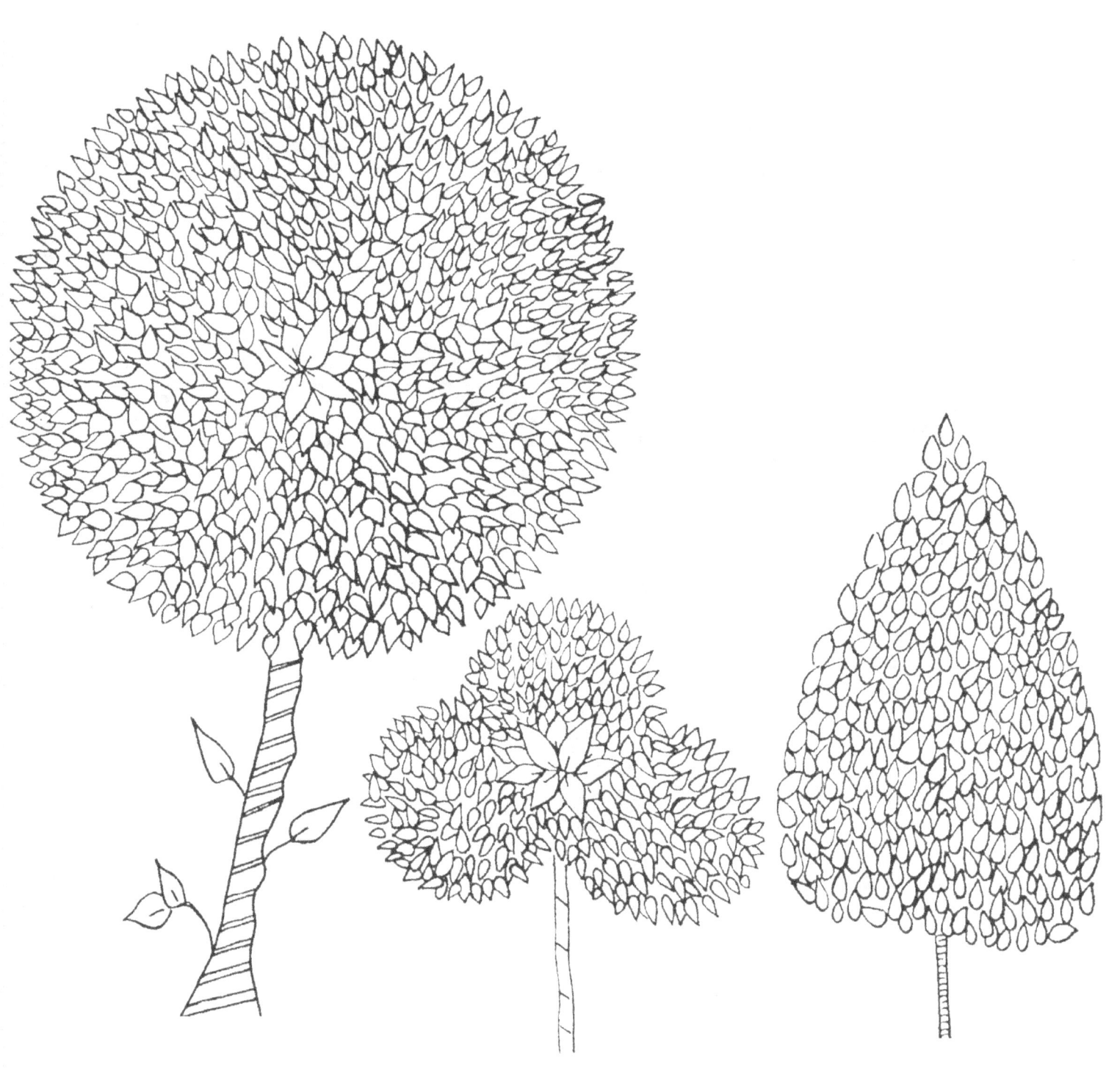

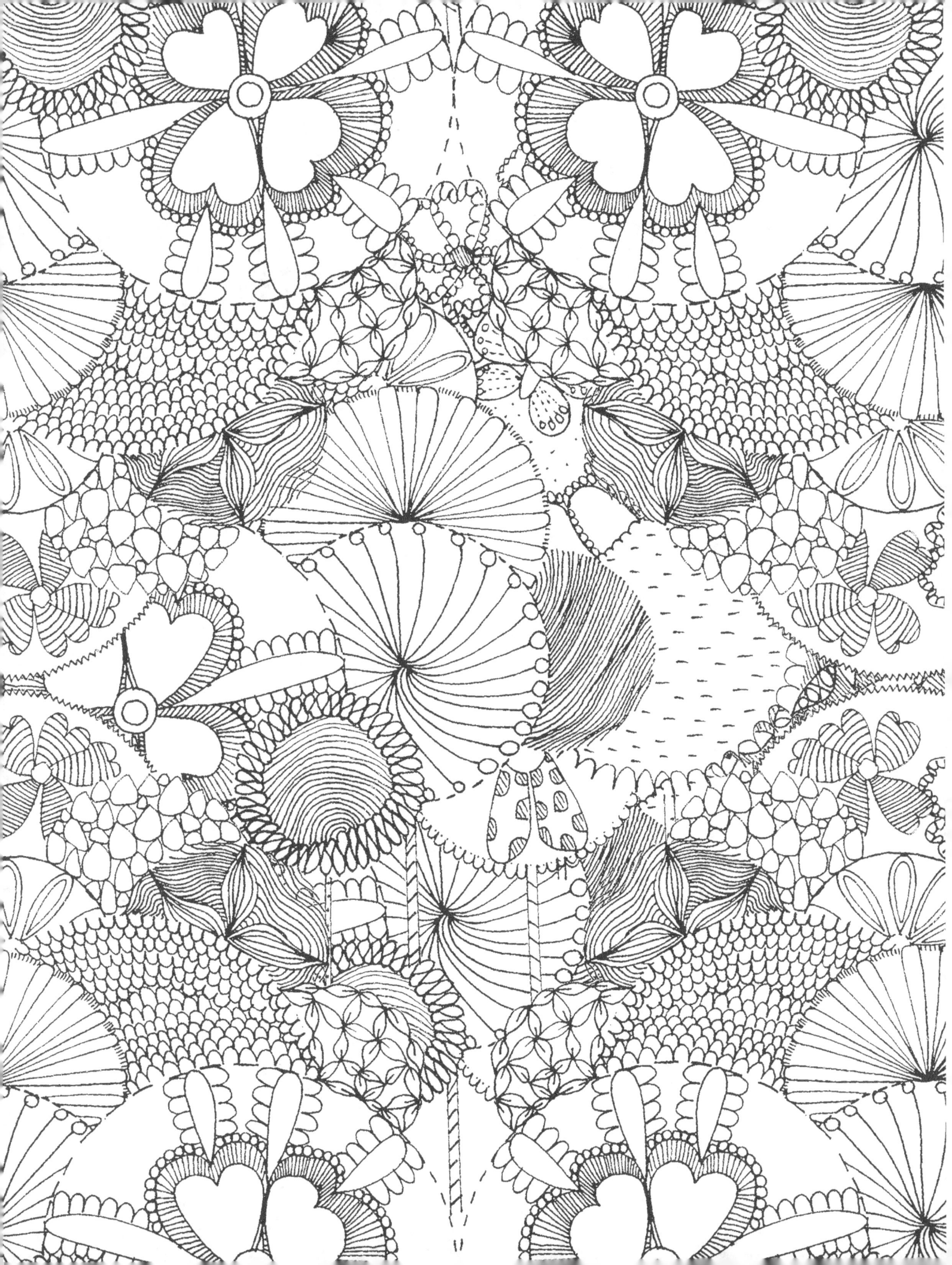

Color Palette Test Page...

www.ingramcontent.com/pod-product-compliance
Lightning Source LLC
Chambersburg PA
CBHW081114180526
45170CB00008B/2841